D0862793

IMAGES
of America

SCULPTURE OF BROOKGREEN GARDENS

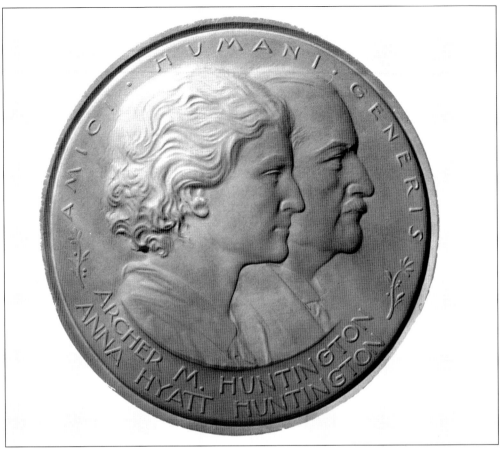

The first medal in the Brookgreen membership series was designed in 1970 by Carl Paul Jennewein, a renowned sculptor and chairman of Brookgreen's board of trustees. His design for the obverse, shown here in plaster, featured portraits of Anna Hyatt Huntington and Archer Milton Huntington, founders of Brookgreen Gardens. This design also was adapted in 1995 as the logo for the Huntington Society, Brookgreen's highest membership category. (Courtesy of the Brookgreen Gardens Archives.)

ON THE COVER: The north wing of the sculpture garden (later known as the upper right wing) featured the bronze sculptures *Faun* by Leo Lentelli (right), and *Seaweed Fountain* by Beatrice Fenton (left). Both sculptures by award-winning artists were acquired in 1932 and were placed in 1934. The entrance to the Gallery of Small Sculpture is visible in the background. (Courtesy of the Brookgreen Gardens Archives.)

IMAGES
of America

SCULPTURE OF BROOKGREEN GARDENS

Robin R. Salmon

ARCADIA
PUBLISHING

Copyright © 2009 by Robin R. Salmon
ISBN 978-0-7385-6656-6

Published by Arcadia Publishing
Charleston SC, Chicago IL, Portsmouth NH, San Francisco CA

Printed in the United States of America

Library of Congress Control Number: 2009931545

For all general information contact Arcadia Publishing at:
Telephone 843-853-2070
Fax 843-853-0044
E-mail sales@arcadiapublishing.com
For customer service and orders:
Toll-Free 1-888-313-2665

Visit us on the Internet at www.arcadiapublishing.com

*This book is dedicated to all of the talented American sculptors,
past and present, represented in the collection of Brookgreen Gardens.*

CONTENTS

ACKNOWLEDGMENTS

I give special thanks to my coworkers in the Brookgreen Gardens collections department—Jeff Hall, Laura Brown Hunnicutt, and Barbara Stone—for their assistance during the writing process. Their organizational skills, helpful suggestions, and good humor helped to move the project along. I also thank the Brookgreen Gardens board of trustees and president Robert E. Jewell for their support.

Many of the photographs in this publication were taken by Frank G. Tarbox Jr., Brookgreen's first horticulturist and director, and by his nephew, Gurdon L. Tarbox Jr., who was director and later president from 1963 to 1994.

Some of the garden scenes photographed in the late 1930s were made by Arden Gallery of New York City, a firm hired to promote Brookgreen Gardens through photographic exhibitions in its Park Avenue gallery. During the same time period, Archer Huntington also hired the New York architectural photography firm Tebbs-Knell Photographers and North Carolina photographer Bayard Wootten (1875–1959) to document the collection. There also are several photographs from the studio of sculptor Richard McDermott Miller that are now owned by Brookgreen Gardens. Unless otherwise noted, the images appearing in this book are from the Brookgreen Gardens Archives.

INTRODUCTION

In 1930, Archer Milton Huntington (1870–1955) and his wife, Anna Hyatt Huntington (1876–1973), purchased property on the coast of South Carolina between Murrells Inlet and Pawleys Island. Anna Hyatt Huntington, a prominent American sculptor, had been diagnosed with tuberculosis just a few years after their marriage in 1923. Their original plan in purchasing Brookgreen Plantation and three adjacent plantations had been to build a winter home that would serve as a retreat from the world while she recovered her strength.

Within a year, they decided to create an outdoor museum to exhibit sculpture among native plants and animals, and to establish a nonprofit corporation to protect and operate it. Brookgreen Gardens opened to the public in 1932, and by 1934, it had grown to include several garden areas featuring landscaped settings for sculpture interspersed with reminders of the 18th-century plantation. Eventually the property expanded to include a total of 9,127 acres, with about 350 acres open to the public and the remainder left as natural habitat for wildlife and undisturbed archaeological sites.

In 1931, at the founding of Brookgreen Gardens, Archer Huntington wrote,

> Brookgreen Gardens is a quiet joining of hands between science and art. The original plan involved a tract of land from the Waccamaw River to the sea in Georgetown County, South Carolina, for the preservation of the flora and fauna of the Southeast. At first the garden was intended to contain the sculpture of Anna Hyatt Huntington. This gradually found extension in an outline collection representative of the history of American sculpture, from the nineteenth century, which finds its natural setting out of doors. . . . Its object is the presentation of the natural life of a given district as a museum, and as it is a garden, and gardens have from earliest times been rightly embellished by the art of the sculptor, that principle has found expression in American creative art . . . leaving to this venture, the presenting of the simple forms of nature and of natural beauty together with such artistic works as may express the objects sought. . . . In all due homage to science, it may be well not to forget inspiration, the sister of religion, without whose union this world might yet become a desert.

In these words, Archer Huntington set specific parameters for the collection that have not changed in more than 75 years. The focus of the collection is American figurative sculpture. The Huntingtons intended the artists to be American citizens and the sculpture to be figurative in that the style of the work was representational or realistic.

The sculpture collection of Brookgreen Gardens began with a few works from the private collection of Archer and Anna Huntington. As a group of objects, it reflected the preferences of these patrons of art. They went on to purchase and to commission works specifically for Brookgreen Gardens. In the 1930s, using William J. Drake of the Gorham Company Bronze Division as intermediary, Anna Huntington searched for sculpture by using three criteria: quality, medium, and price.

In 1978, nearly 50 years later, Brookgreen Gardens was placed on the National Register of Historic Places. The 50-year existence requirement for register status was waived as a result of the national significance of the sculpture collection. In 1992, Brookgreen Gardens (and Atalaya, the Huntingtons' winter home) was designated as a National Historic Landmark in recognition of Anna Hyatt Huntington's importance as a sculptor and patron of the arts, and because of Brookgreen's significance as a site for women's history in America due to the number of women artists represented in the sculpture collection.

The locations of sculptures cited in the text of this book pertain to names of buildings, galleries, and garden spaces that were in use at the time the sculptures were acquired. Through the years, the names of buildings and garden areas have changed to reflect new acquisitions and donors, and some garden names, though still in existence, are not in common usage.

For example, the name of the indoor-outdoor Gallery of Small Sculpture was shortened to the Small Sculpture Gallery in the late 1970s and has been known as the Mary Alice and Bennett A. Brown Sculpture Court since 1998.

The Visitors Pavilion housed Brookgreen Gardens' permanent indoor gallery space from 1968 through 1996, when it became the Callie and John Rainey Sculpture Pavilion, housing temporary exhibitions.

The South Carolina Terrace existed until 2004, when it was designated the Brenda W. Rosen Carolina Terrace.

The Baby Garden, located in front of the former Gallery of Small Sculpture (now the Brown Sculpture Court), is still extant but rarely referred to by that title due to its proximity to the Peace Garden Room for Children, which opened in 1999.

Likewise, the Boxwood Garden still exists but is more often referred to as the Center Garden because of its central geographic location.

Today the brick Bird Tower in the gardens, which once provided space for nesting birds, is known as the Bell Tower because it now supports a large bell that once was located at Atalaya, the Huntingtons' winter home.

All of these changes reflect Brookgreen Gardens' dynamic nature and its ability to grow and adapt throughout its 78-year history.

Today the sculpture collection is recognized as the finest of its kind in the world.

One

ACQUISITIONS IN THE 1930s

The first decade of Brookgreen's history—the 1930s—was a time of rapid growth and development for the new organization. During this period, Archer and Anna Huntington frequently were on-site and hands-on as they made decisions and guided the building of a collection of American figurative sculpture, a botanical garden, and a zoological facility. The original sculpture gardens and zoo were completed during this short period.

Major sculptures were commissioned and acquired such as *Dionysus* by Edward McCartan and *Evening* by Mario Korbel, and important works by Anna Hyatt Huntington were installed, including *Diana of the Chase*. The innovative and roofless Gallery of Small Sculpture was built to exhibit small works in an outdoor environment. Working anonymously through representatives of the Gorham Company and Arden Gallery in New York City, the Huntingtons (primarily Anna) made selections from photographs of clay and plaster models as well as completed sculptures. In the beginning, sculptors did not know the identity of the anonymous client or the destination of their works.

By the end of the decade, nearly 350 sculptures had been acquired by the Huntingtons for Brookgreen Gardens, including some of the most famous works by the most important sculptors in the collection. *The Puritan* by Augustus Saint-Gaudens, *Diana* and *Actaeon* by Paul Manship, and *Benediction* by Daniel Chester French were among the landmark sculptures that helped increase Brookgreen's significance. The first sculpture purchased specifically for Brookgreen Gardens was *Forest Idyl*, a life-size bronze by Albin Polášek, acquired on August 6, 1930 from the Gorham Company.

At first, bronze was the medium of choice; then Anna Hyatt Huntington shifted emphasis away from metal in favor of stone, even requesting that works under consideration should be carved in stone rather than cast in bronze. A pioneer in the use of cast aluminum in the 1930s, Huntington also ordered some of her own sculpture and works by other artists to be cast in aluminum for the collection. During the first 10 years of Brookgreen Gardens' existence, sculpture entered the collection as gifts of the Huntingtons or occasionally of other donors, including sculptors.

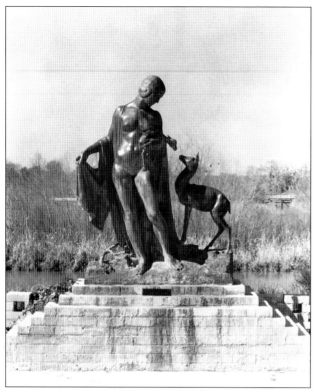

The first sculpture purchased specifically for the Brookgreen collection was *Forest Idyl*, a bronze by Albin Polášek. The sculpture featured a young female figure with a deer and fawn in a pyramidal composition. Acquired in 1930, it was placed at the center of the walk on the western edge of the gardens along the old rice fields in 1932.

Below, a distant view of *Forest Idyl* by Albin Polášek, silhouetted against a panoramic backdrop, reveals the open appearance of the west side of the sculpture garden in the 1930s. Old rice fields and bridges along dikes from the plantation era are evident in the background. The cement blocks placed on the ground at the sides of the sculpture were formed to be used as seats throughout the gardens.

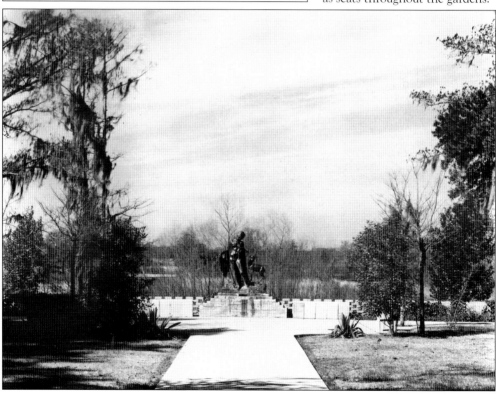

Boy and Squirrel by Walker Hancock was acquired in 1932 and was placed in an oval at the head of the Live Oak Allée in 1934. The sculpture was modeled in Rome while Hancock was a student at the American Academy in 1928. It was later carved in Batesville marble for Brookgreen Gardens.

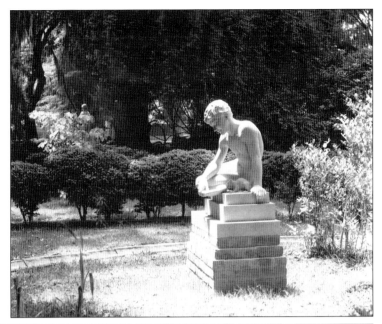

A distant view of *Boy and Squirrel* by Walker Hancock looks down the Live Oak Allée toward the entrance of the sculpture garden. The moss-draped oaks and the boxwood encircling the sculpture were remnants from the Brookgreen Plantation. Note the concrete trough that allowed water, pumped from a reservoir, to irrigate the area.

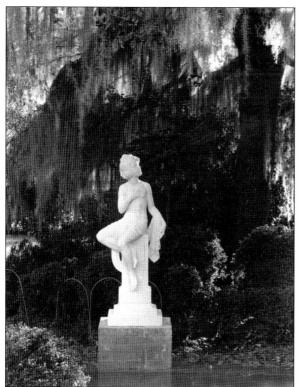

The Moonbeam by Abram Belskie was one of several white marble sculptures acquired by the Huntingtons. Anna Hyatt Huntington wrote, "I must, wherever possible, have stone compositions—a garden made up entirely of bronze pieces becomes monotonous and very much needs a careful introduction of various stones and marble to break this monotony."

Maidenhood was created by George Grey Barnard in 1896 using chorus girl Evelyn Nesbit as the model. She became notorious in the early 20th century as the mistress of Beaux-Arts architect Stanford White and the wife of millionaire Harry K. Thaw, who shot and killed White during a public event on the rooftop of Madison Square Garden. The building behind the sculpture is the kitchen from Brookgreen Plantation.

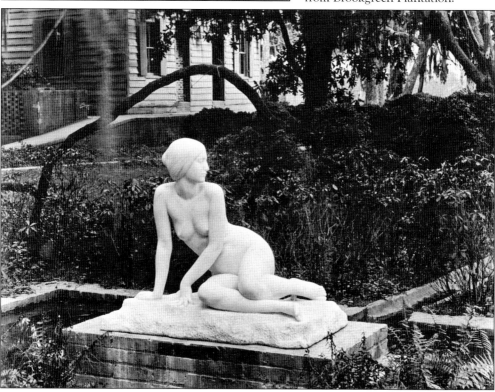

The white marble sculpture *Sylvan* (also known as *Youth*) came to Brookgreen in 1932 from Archer Huntington's Fifth Avenue townhouse in New York City. Sculpted by Chester Beach, *Sylvan* was placed in the center of the garden surrounded by a hedge and remained there until it was moved to a location in front of the Old Kitchen in 1937.

The white marble sculpture *Autumn Leaves* by Hilda Gustafson Lascari was acquired in 1936 shortly before the death of the sculptor. The sculpture's serene beauty belies the fact that Lascari suffered from severe depression and eventually committed suicide. In the background are *Lion* by Sidney Waugh (right) and *The Whip* by George Holschuh (left).

13

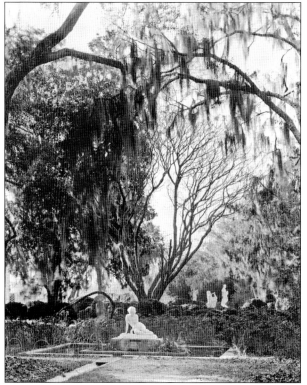

Three important acquisitions in the 1930s were, from left to right, *Sylvan* by Chester Beach, *Sonata* by Mario Korbel, and *Autumn Leaves* by Hilda Lascari. They were placed in the Boxwood Garden, located at that time in the center of the gardens in front of the Old Kitchen.

Maidenhood by George Grey Barnard, *Autumn Leaves* by Hilda Lascari, *Sonata* by Mario Korbel, and *Sylvan* by Chester Beach are shown in the Boxwood Garden, located in front of the Old Kitchen in February 1938. The quartet of marble sculptures created beautiful white accents among the dark foliage.

The Afternoon of the Faun (also known as *L'-Après-midi d'un Faune*) by Bryant Baker was commissioned in 1934. Anna Hyatt Huntington wanted the sculpture enlarged from a small model made for bronze casting and cut in stone. Baker at first refused, saying it was not possible to carve the delicate design in stone. As shown, he solved the problem by leaving stone "bridges" to support the most slender areas. The bridges were cut away after the carving was completed.

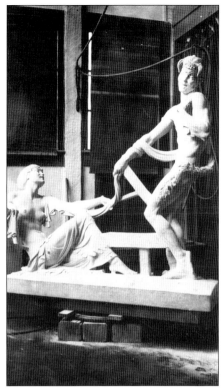

The Afternoon of the Faun (also known as *L'-Après-midi d'un Faune*) by Bryant Baker was placed in the lower left wing of the sculpture gardens in 1934. Unfortunately it was damaged in shipping and broke in several places along the drapery between the two figures. Nevertheless the sculpture was assembled, repaired, and placed on exhibition.

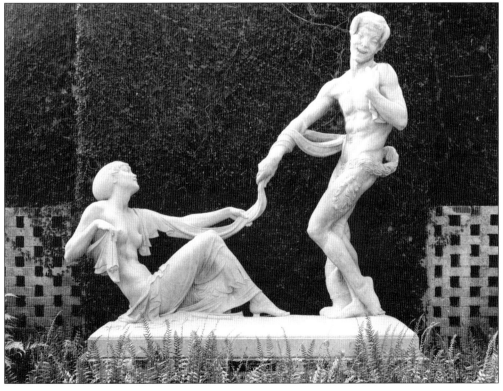

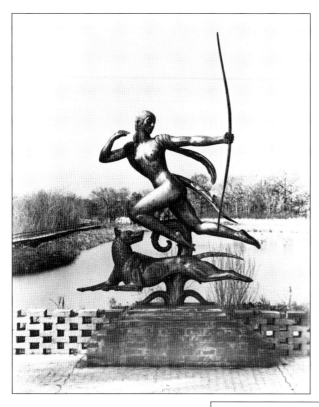

Diana by Paul Manship was acquired in 1936 and was placed on the northwestern edge of the sculpture garden overlooking the old rice fields. This large bronze sculpture measures 7 feet, 3 inches from its base to the tip of the bow. Note the boardwalk along the dike that leads to a dock on Brookgreen Creek.

Actaeon by Paul Manship, the companion to *Diana*, was placed on the southwestern edge of the gardens overlooking the rice fields in 1936. Both sculptures were fully gilded and featured enameled eyes. In the late 1980s, the positions of the two sculptures were swapped in order to achieve symmetry and better interpretation of the subject matter of the artworks.

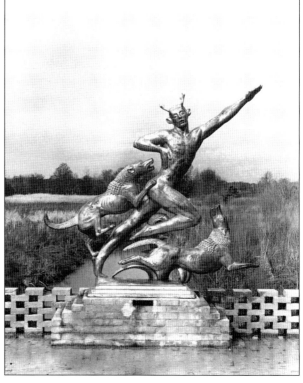

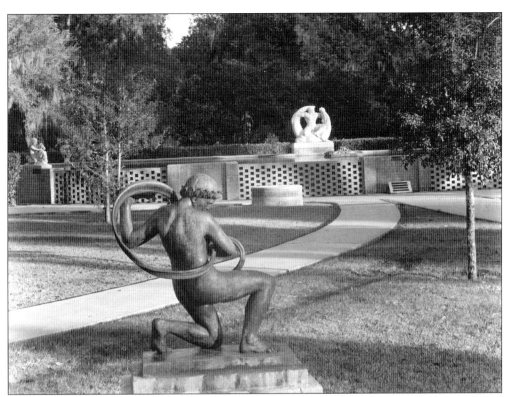

Joan Hartley's pair of male and female *Furies* was acquired in 1934 and was placed on the South Carolina Terrace across the back of the gardens. Shown is the female *Fury* with the Alligator Bender Pool in the background. Also shown, from left to right, are *Little Lady of the Sea* by Ernest Haswell, *Alligator Bender* by Nathaniel Choate, and *Alligator Fountain* by Anna Hyatt Huntington.

The male *Fury* by Joan Hartley is shown on the South Carolina Terrace with *Adam* and *Eve* by Janet de Coux, placed as gateposts in the background. The de Coux sculptures, cast in lead, were acquired in 1936 and placed in 1937. The *Fury* was acquired and placed in 1934.

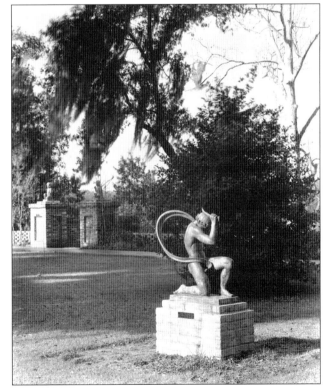

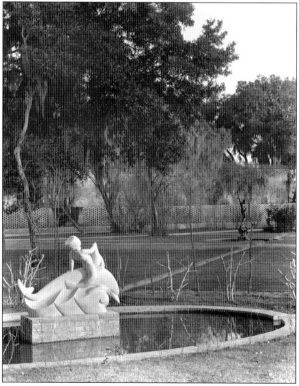

Pelican and *Concave-casqued Hornbill* by Paul Manship are shown atop posts at the head of steps that originally led to the boat landing for Brookgreen Plantation. The bronze sculptures are two of 10 examples of birds created by Manship for the Paul Rainey Memorial Gate at the Bronx Zoo. Brookgreen acquired all of them in 1937.

A photographer working for the Arden Gallery photographed the upper left wing of the gardens in February 1938. In the foreground is *Triton on Dolphin*, a limestone sculpture by Benjamin Franklin Hawkins that was acquired in 1937. Also visible are *The Guardian* by Sahl Swarz (left) and *The Young Diana* by Anna Hyatt Huntington (right).

Sonata, a beautiful white marble sculpture by Mario Korbel, was one of two pieces acquired from him in 1934. The figure's design, originally titled *Music*, was one of five works commissioned in 1922 for the estate of George G. Booth in Birmingham, Michigan. A version in bronze won the Goodman Prize at the Grand Central Art Galleries in 1929.

Dionysus, a life-size gilded bronze sculpture, was enlarged and remodeled in 1936 by Edward McCartan at the request of Anna Hyatt Huntington after seeing a photograph of an earlier small version. At first, *Dionysus* was placed on a low pedestal in front of the heart-shaped hedge in the center of the gardens, shown in this photograph. It was later moved into the center of the heart and elevated on a higher pedestal in order to preserve the gold-leafed surface.

Through the 1930s, many of the works for the open-air Gallery of Small Sculpture were purchased, so that by the end of the decade, nearly 350 sculptures had been acquired by the Huntingtons for Brookgreen Gardens. *Frog Baby*, a playful sculpture by Edith Barretto Parsons, was placed in the gallery's central pool in 1934. It is one of a series of fountain figures by Parsons that achieved public acclaim in the early 20th century.

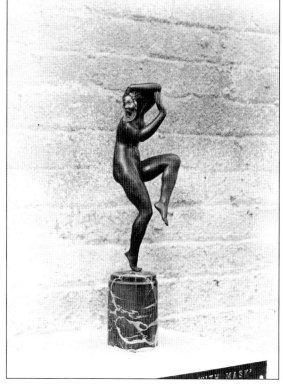

The first sculpture formally accessioned into the collection was *Comedy*, a small bronze statue by Carl Paul Jennewein. It was created around 1920 while Jennewein was living in Rome and studying at the American Academy. Purchased in 1924 by Archer Huntington for his personal collection in New York, *Comedy* was transferred to Brookgreen in 1931 and was placed in the Gallery of Small Sculpture.

The pair of exuberant *Rearing Horses* by Frederick MacMonnies was acquired in 1932 and was placed in the Gallery of Small Sculpture in 1934. These were reductions of the original over-life-size sculptures created in 1898 for the Park Circle entrance to Prospect Park in Brooklyn, New York. First titled *The Triumph of Mind over Brute Force*, the sculptures are also known as *The Horse Tamers*. To create the sculptures, MacMonnies borrowed a pair of Andalusian horses to use as models, brought them to his Paris studio, and positioned them through the use of slings, ropes, and pulleys.

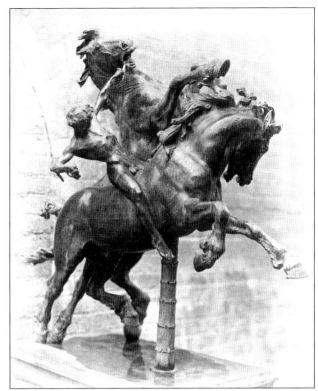

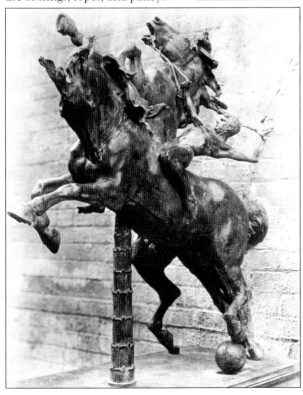

The back of the Gallery of Small Sculpture showcased the bronze female figure *Rain* by Avard Fairbanks, which was acquired in 1936. Embodying the concept of rain in art deco–inspired patterns in the headdress and in water dripping over the shoulders and arms, the sculpture was immediately popular with Brookgreen visitors. On the right is one of a pair of *Rearing Horses* by Frederick MacMonnies, acquired in 1932.

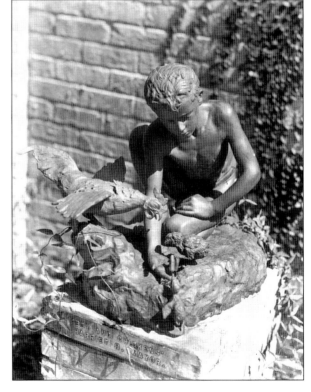

Harriet Hyatt Mayor, the older sister of Anna Hyatt Huntington, was also a talented sculptor. Her body of work focused on portraits and figures of children, such as *Boy and Chickens*, done in 1896 and exhibited at the Boston Art Club in 1898. *Boy and Chickens* was acquired and placed in the Gallery of Small Sculpture in 1935.

The Guardian by Sahl Swarz was purchased and placed in 1937 when the sculptor was only 25 years old. The life-size group in bronze depicts a young male standing with a long bow and an alert dog seated at his feet. It is shown in the raised planting bed in the upper left wing of the gardens.

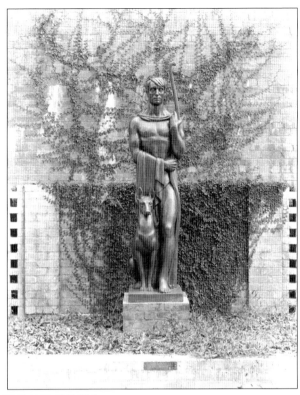

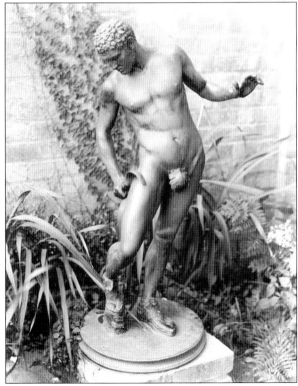

One of the older sculptures in the collection, *The Scraper* by Charles Henry Niehaus, was created in Rome in 1883. Originally titled *Greek Athlete Using a Strigil*, the sculpture has a companion piece, *Caestus*, a figure of an ancient boxer binding his hands. *The Scraper* was acquired in 1933 and was placed in a raised bed in the lower left wing in 1935.

Reflected at sunset on the edge of the raised pool on the South Carolina Terrace, *Alligator Bender* was created for the space. The Huntingtons commissioned Nathaniel Choate to enlarge a small design that he had carved in mahogany in 1926. During the enlargement, he made the figure more robust to look like a Seminole Indian. Choate carved the sculpture in Italy in 1937, and it was placed in its current location in 1938.

The back of *Alligator Bender* by Nathaniel Choate is shown in this view across the raised pool toward the gateposts of the south steps at the rear of the gardens. The steps were added by Archer Huntington to match the original flight of steps that led to a 19th-century boat landing. On the left is *Sea Scape* by Herbert Adams, placed in 1934, and on the right is *Alligator Fountain* by Anna Hyatt Huntington, acquired in 1937.

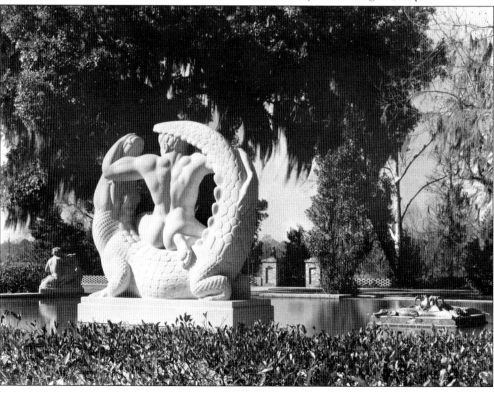

Sea Scape by Herbert Adams was carved in limestone in 1935 and was placed on the edge of the circular raised pool at the back of the gardens. Relating in theme to other figures around the pool edge, *Sea Scape* depicts the joyfulness of an imaginative child at play. To the right is *Girl with Dolphin*, carved by Milton Horn in 1929 and acquired in 1936.

Little Lady of the Sea by Ernest Haswell is one of four playful figures around the edge of the raised pool. Acquired in limestone for Brookgreen in 1934, it was created in 1929 and was cast in bronze for the Tyler Field Gardens. The sculpture is also known as *Little Lady Godiva*. To the right is *Boy with Dolphin* by Milton Horn.

Augustus Saint-Gaudens's landmark sculpture, *The Puritan*, was among the first 19th-century works to incorporate asymmetry, forward movement, and accurate historic details. Created in 1887 as a life-size monument to Deacon Samuel Chapin, one of the founders of Springfield, Massachusetts, *The Puritan* was reduced in size in 1897 and cast in 1899. The Huntingtons acquired it from the Gorham Company in 1932 and placed it in the raised bed along the Live Oak Allée in 1934.

The Youthful Franklin by R. Tait McKenzie was commissioned in 1910 and was unveiled at the University of Pennsylvania in 1914, a gift of the graduating class. McKenzie depicted Benjamin Franklin as a young man walking to Philadelphia. He used an 18th-century bust by Jean-Antoine Houdon as a model for the face. Archer and Anna Huntington acquired this casting in 1932 and placed it in a raised planting bed on the Live Oak Allée in 1934. Tait McKenzie was a medical doctor and a sculptor known for his studies in physical education and sculpture of athletes in exertion.

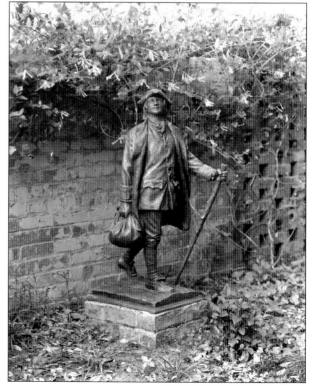

Zeus by Robert Aitken was created as a sketch model or maquette for a competition to design a heroic figure for the top of the American Telephone and Telegraph Building in New York. Although Aitken did not win the competition, his sculpture was exhibited in 1915 at the Panama-Pacific Exposition in San Francisco in the Gorham Company exhibit. It was acquired for Brookgreen Gardens in 1932 and was placed in a raised bed on the Live Oak Allée in 1934.

Many of the early outdoor sculptures acquired for Brookgreen depict children at play. *Two Kids* by Oronzio Maldarelli features patterns of diagonals with the child's and the goat's bodies placed in opposition. The sculpture was cast in lead and was acquired in 1936. It was placed in a raised bed in the lower left wing of the gardens in 1937.

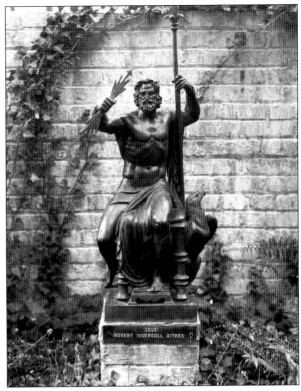

Henry Hering's *Wood Nymphs* were among the sculptures cast in aluminum for Brookgreen at the request of Anna Hyatt Huntington (the first sculptor to use aluminum as a casting medium). Combining elements of music, mythology, and natural history, they are examples of ornamental garden figures of the era. The *Wood Nymphs* were created in 1932, were purchased in 1935, and were placed in matching niches in the upper right wing in 1936. Henry Hering was a versatile sculptor known for architectural, portrait, monumental, and medallic sculpture. He worked with Philip Martiny and Augustus Saint-Gaudens, two eminent American sculptors of the late 19th century, before opening his own studio.

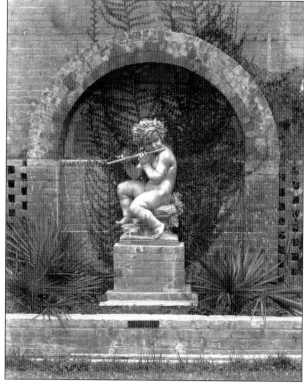

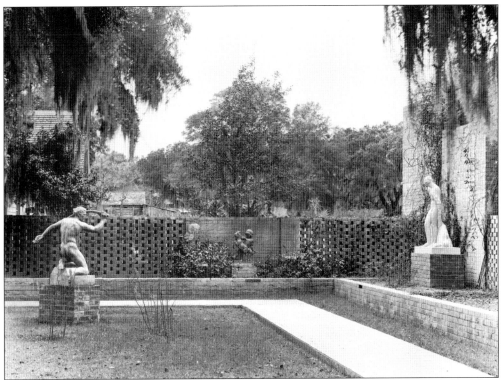

The south wing of the sculpture gardens (later known as the lower left wing) contained several works in various media by the end of the 1930s. Shown from left to right are *The Whip* by George Holschuh (bronze), *Two Kids* by Oronzio Maldarelli (lead), and *Pastoral* by Edmond Amateis (Tennessee marble). The buildings visible over the wall in the background were part of the property of Dr. Joshua John Ward Flagg, whose grandfather Joshua John Ward owned Brookgreen Plantation during the antebellum period.

Several years after it was acquired, *Pastoral*, a three-fourths life-size carving in Tennessee marble by Edmond Amateis, was moved from the lower left wing and relocated to a small, lily pad-filled pool close to the center of the gardens. Originally titled *Mirifiore*, the sculpture was modeled in Rome during the summer of 1924 while Amateis was studying at the American Academy. It was acquired in 1936 and was placed first in 1937.

The West Alston Walk, located in the center of the gardens, is shown in a late-1930s photograph. The sculpture is *Boy and Panther* by Rudulph Evans, acquired in 1936 and placed there in 1937. Its subject was Mowgli, a character from *The Jungle Book* by Rudyard Kipling. The brickwork in the background was built and planted with wisteria to attract birds and to camouflage a dead tree trunk. To the right of the brickwork, behind the hedge, is a large *Camellia japonica* from the 19th century.

In the late 1930s, the South Carolina Terrace across the back of the sculpture garden was a majestic space with wide lawns, spreading live oaks, and other native plants. On the left is *Faun* by Leo Lentelli, and in the distance on the right is the pair of *Furies* by Joan Hartley. All of the sculptures were placed in 1934.

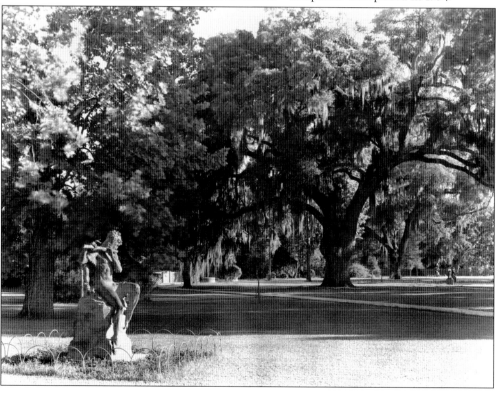

Daniel Chester French's ability to depict a sense of mystery is evident in *Benediction*, a figure dating from 1922. The sweep of wings and folds of drapery enhance the power and majesty of the compassionate figure, arms raised in blessing. It was designed as a World War I memorial for Massachusetts soldiers near Verdun, France, but the project did not come to fruition. The Huntingtons acquired the sculpture in 1932 and placed it in a raised bed along the Live Oak Allée in 1934.

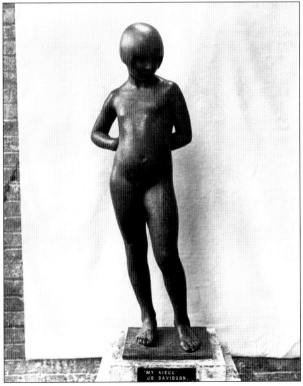

Jo Davidson was acclaimed for the portrait busts and heads he completed of dignitaries, entertainers, heads of state, and men and women of arts and letters. Lauded for his ability to capture personality as well as likeness, Davidson expressed this talent in *My Niece*, a portrait of his 10-year-old niece, done in 1930. It was acquired and placed in 1936 on the Old Kitchen Terrace.

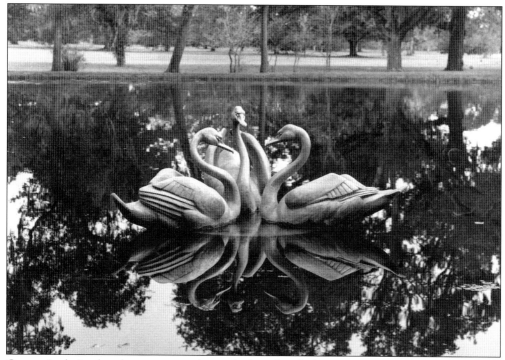

Gaston Lachaise, best known as a sculptor of robust female figures expressing the idea of woman as a cosmic force, also sculpted animals. Anna Hyatt Huntington selected a trio of *Swans*, originally designed for the garden of Philip Goodwin at Locust Valley, New York. They were cast in aluminum in 1937 and were placed on a bronze base in the Dogwood Pond on the north side of the sculpture gardens in 1938. In the background is the Brookgreen Arboretum.

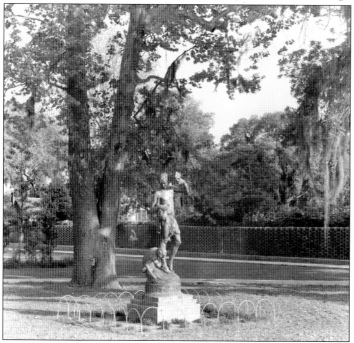

Charles Keck designed *Fauns at Play* in 1921 for the J. J. Raskob Estate at Centreville, Maryland. There it was set into a marble basin carved with a frieze representing the Raskob children at play. The example acquired for Brookgreen in 1932 is the only other casting of this work. The sculpture was placed in the upper left wing of the gardens in 1934. In the background is *Meditation* by Ernest Wise Keyser.

Two

Domestic and Wild Animal Sculpture

The 19th-century French *animaliers*, or sculptors of animals, made a great impression upon American sculptors. By the 1870s, Edward Kemeys (1843–1907) was producing sculpture of native animals that he observed on his many trips to the American West. His most famous work, *Still Hunt*, a tense mountain lion about to seize its prey, was created in 1881 and was placed in Central Park two years later. Although his work was not always technically or anatomically perfect, Kemeys was the first American sculptor to devote his career to the depiction of native wild animals.

Following in his footsteps were men employed by America's natural history museums. They served as taxidermists, exhibit designers, curators, and collectors for such places as the Smithsonian Institution in Washington, D.C., the American Museum of Natural History in New York City, and the Field Museum of Natural History in Chicago. Prominent among this group in the early 20th century were Carl Akeley (1864–1926), James Lippett Clark (1883–1969), and Robert Henry Rockwell (1885–1973).

Anna Hyatt Huntington (1876–1973) made a name for herself as a sculptor of animals in 1908 when her pair of jaguars was exhibited at the Paris Salon. Chicago art historian and sculptor Lorado Taft praised these artworks writing: "Verily they are among the most original things in American art."

Another group of animal sculptors in America included Louis Paul Jonas (1894–1971), Albert Laessle (1877–1954), and his student, Ralph Hamilton Humes (1902–1981). Each sculptor invested his work with experience in taxidermy, anatomy, and scientific observation. While Laessle often focused on the personalities of his animal subjects, Jonas established a career as a sculptor and a creator of displays and models for museums and expositions. Ralph Hamilton Humes initially came to sculpture as therapy after his hands were injured during World War I. He eventually became one of the most respected animal sculptors of the 20th century.

Contemporary sculptors of native and exotic wildlife have carried on the legacy of their predecessors, blazing individual paths toward recognition and public acquisitions of their works.

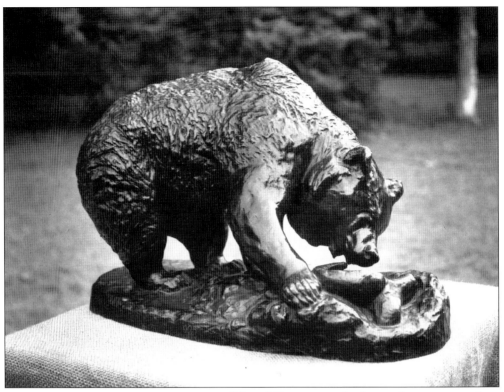

Edward Kemeys was the first sculptor to recognize the artistic possibilities of native animals as subjects. *A Grizzly Grave Digger* depicts a grizzly bear nudging the head of a bighorn sheep with its nose while scraping the earth with its right front paw. The date of this work is not known, but the original model was part of a group presented to the United States National Museum in 1883. It was acquired by Brookgreen at auction in 1986 and was placed in the Small Sculpture Gallery.

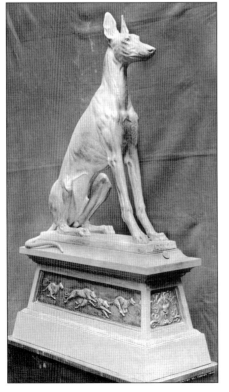

Adonis, a life-size seated greyhound, was created in 1905 by Eli Harvey. The sculptor inscribed the base: "Young Greyhound 8 Months Old." In this photograph, the sculpture is exhibited on an ornamental pedestal with reliefs depicting racing greyhounds on the sides and a lion head on the front. *Adonis* was acquired by the Huntingtons in 1932 and was placed in the upper left wing in 1934.

Charles Cary Rumsey's *Hound*, one of a pair, was acquired with its mate and was placed at the entrance to the Gallery of Small Sculpture in 1936. The base is festooned with reliefs of rabbits and foxes. The *Hounds* were created around 1910 as andirons for the home of Rumsey's mother-in-law, Mrs. E. H. Harriman, in Arden, New York.

Eli Harvey was known for sculptures of lions, a favorite subject, depicted in various poses and sizes. This small sculpture, *Young Lion with Rabbit*, one of his earliest works, was modeled in Paris in 1897. It was acquired by the Huntingtons in 1936 and was placed in the Gallery of Small Sculpture in 1937.

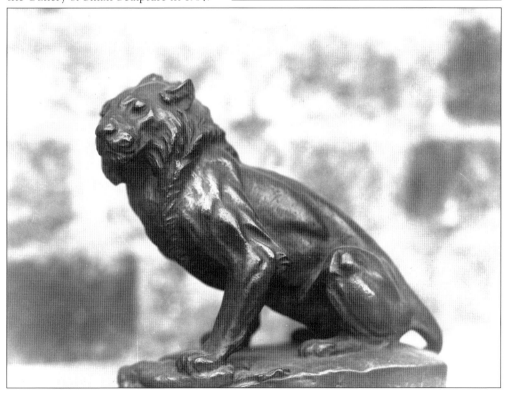

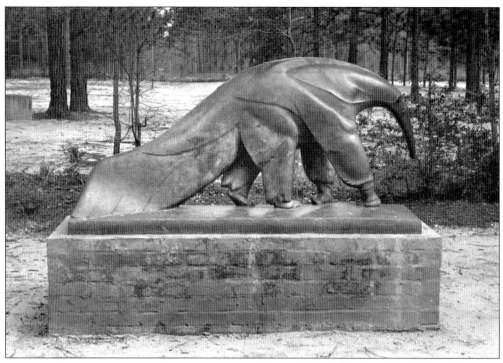

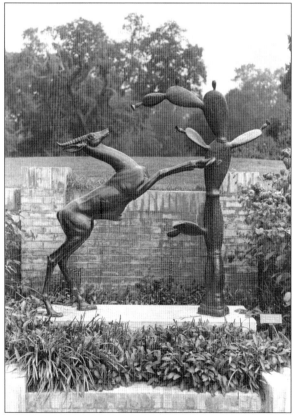

Erwin Springweiler's *Great Anteater* was created in 1938 for a location in front of the small mammal house at the National Zoo in Washington, D.C. He was able to work from a live anteater there and from skeletons and furs at the American Museum of Natural History. Another casting was acquired for Brookgreen in 1947 and was placed at the Brookgreen Zoo in 1949. Today *Great Anteater* is exhibited in the Peace Garden Room for Children.

Early in his career in Rome, Albino Manca modeled a small sculpture of a rearing gazelle with its front legs on the branches of a tall cactus. *Gazelle and Cactus* was enlarged and, after Manca came to America, shown at the 1939 New York World's Fair. In 1943, it received the Medal of Honor from the Allied Artists of America. The Huntingtons acquired the sculpture in 1949 and placed it in Brookgreen's new Palmetto Garden in 1950.

Bat by Lawrence Tenney Stevens was created after his studio was infested by bats and they had to be exterminated. He depicted the defiant attitude and expression of rage on the face of one subject. *Bat* was acquired by Anna Hyatt Huntington in 1932 and was placed in the Gallery of Small Sculpture in 1934. It was later moved to the Peace Garden Room for Children.

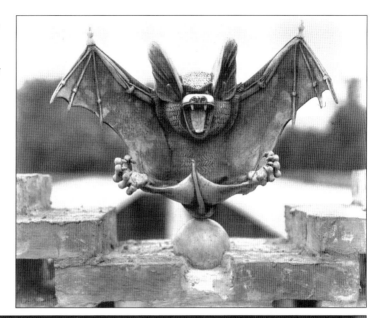

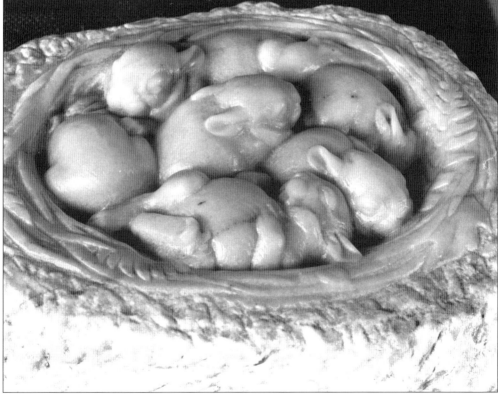

At his Connecticut home, Joseph Boulton discovered a female cottontail with a nest of six young rabbits, brought them all into his studio, and placed them in a cage while he created a clay model over a three-day period. He then carried the cage back to the woods and released them. *Rabbit Nest* was later carved in white marble and was acquired in 1952. It was exhibited in a case in the information center of the Gallery of Small Sculpture.

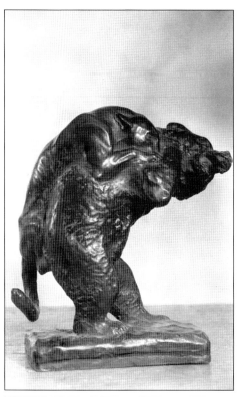

Edwin Willard Deming spent many years living among the native people of the American West and was eventually adopted by the Blackfoot Indian tribe. While his paintings depicted Native American life, his sculptures were mostly of animals. *The Fight*, done in 1906, portrays a powerful struggle between a grizzly bear and a mountain lion. It was acquired in 1936 and was placed in the Gallery of Small Sculpture in 1937.

Joseph Boulton's *Springtime Frolic* is a lively presentation of four grey squirrels, each with an individual personality. The sculpture won the Watrous Gold Medal of the National Academy of Design in 1953, the gold medal of honor of the Hudson Valley Art Association in 1960, and an award from the Connecticut Classic Artists in 1960. Boulton presented it to Brookgreen Gardens in 1964, and it was exhibited in the Gallery of Small Sculpture.

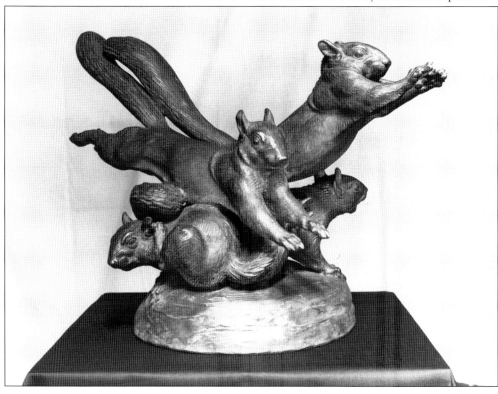

Klipspringer was modeled by Joseph Arthur Coletti in 1927 from studies made at the London Zoo one year earlier. This elegant member of the antelope family is depicted with arched neck and slender legs poised to leap. It was purchased by the Huntingtons from this photograph and was placed in the Gallery of Small Sculpture in 1936.

Prince Paul Troubetzkoy was a Russian nobleman, born in Italy, who lived in Italy, France, Russia, and America before settling in Paris. Archer Huntington acquired this impressionistically modeled *Elephant* for Brookgreen in 1934 and placed it in the Gallery of Small Sculpture. The sculpture was created in 1889 when Troubetzkoy was 23 years old and living in Milan.

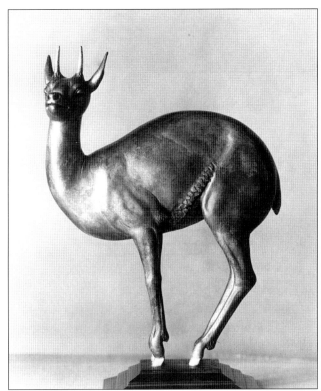

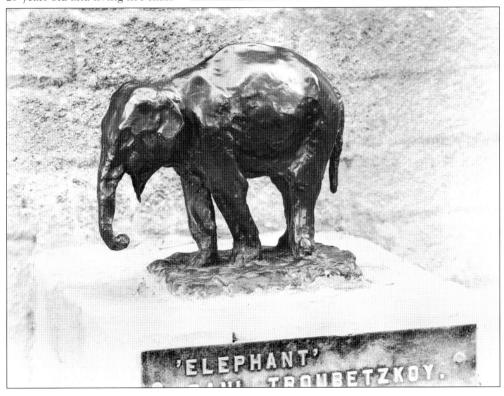

'ELEPHANT'
PAUL TROUBETZKOY.

James Lippitt Clark was a taxidermist, sculptor, and curator at the American Museum of Natural History in the early 20th century. *Spotted Hyena* was created in 1903 as a sketch model before proceeding with a full-size form on which the skin of the animal was mounted for display in the museum. The sculpture was acquired in 1935 and was displayed in the Gallery of Small Sculpture in 1936.

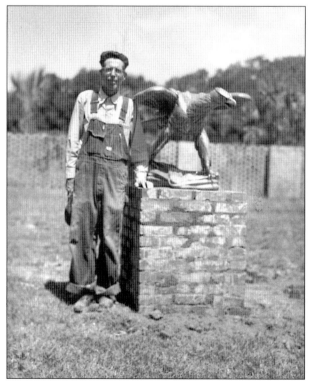

Ralph Hamilton Humes was injured in a bomb blast, causing him to lose an eye and parts of seven fingers. While at Walter Reed Hospital, he became interested in sculpture as therapeutic treatment. Eventually, his ability was noticed, and the government paid for his art training. *The Eagle's Egg* was modeled from earlier sketches and was completed in 1953. It was cast in aluminum at Anna Hyatt Huntington's request and acquired in the same year. The photograph shows workman Hazel Hatchell with the newly installed sculpture in front of the Palmetto Garden wall.

William Hunt Diederich, grandson of painter William Morris Hunt, traveled the world during his career, interpreting animals as his favorite subjects. Diederich's *Goats Fighting* was modeled in Paris during a period when he was also working in wrought iron. The angular style was influenced by that medium. It was acquired in 1936 and was placed in 1937.

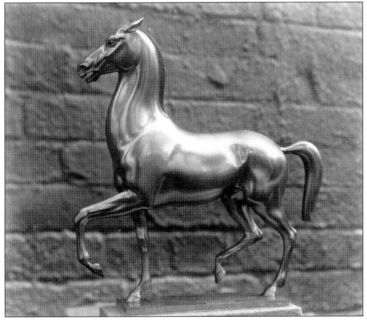

Arab, a prancing stallion by Allan Clark, was modeled in 1929 and was cast in bronze in Munich, Germany. Its gleaming finish is a result of fire-gilding. *Arab* reflects the influence of a three-year study trip to the Far East, where Clark visited and worked in Japan, Korea, China, Cambodia, Java, Malaysia, Thailand, and Burma. It was acquired for Brookgreen in 1935 and was placed in the Gallery of Small Sculpture in 1936.

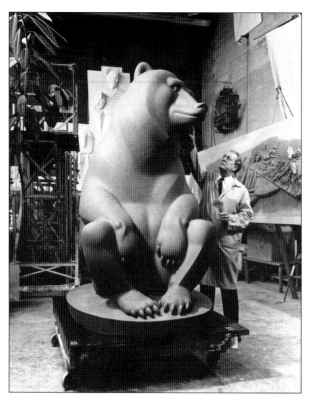

Marshall Fredericks established his career in Michigan after studying and later working with Carl Milles. Fredericks is shown in his studio in Royal Oak, Michigan, working on the clay model of *Mother and Baby Bear* in 1964. The large bronze was acquired in 1985, a partial gift of the sculptor, and is now located in the Peace Garden Room for Children.

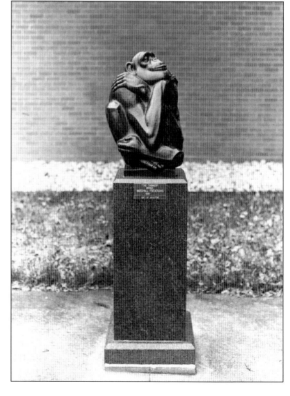

The Thinker by Marshall Fredericks is a tongue-in-cheek representation of a chimpanzee in deep thought. It also reflects the sculptor's sense of humor. The original model was done in 1938 when Fredericks was working on a commission for sculpture for the 1939 New York World's Fair. The bronze casting was acquired in 1982 as a gift of the sculptor and was placed in 1983 outside the Visitors Pavilion on the walkway to the Diana Pool.

Known as an architectural sculptor, Sidney Biehler Waugh designed powerful work for many of the federal buildings in Washington, D.C. His *Lion* was carved in black granite during the same period in 1933. It was acquired by Brookgreen in 1936 and was placed in that same year on the steps going from the lower left wing to the Old Kitchen Terrace.

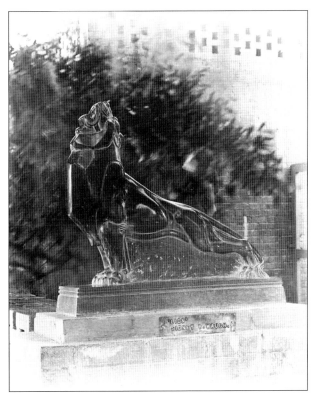

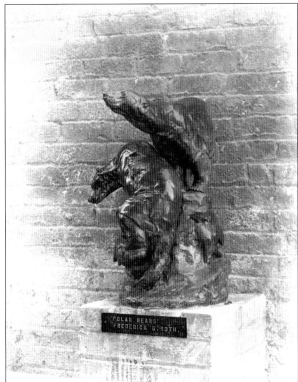

Frederick G. R. Roth depicted this pair of polar bears on a block of ice in his studio in Brussels in 1905. *Polar Bears* led to his election to the National Academy of Design in 1906, and it was awarded the National Arts Club Prize in 1924. Anna Hyatt Huntington acquired the sculpture for Brookgreen in 1932, and it was placed in the Gallery of Small Sculpture in 1934.

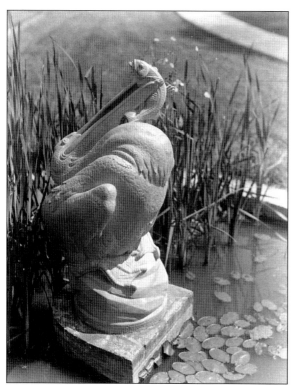

Bruce Moore's *Pelican and Fish* was begun in 1934 and was finished in 1935 in New York. It was created for a fountain in a public park in Pratt, Kansas. The sculpture won the Speyer Prize of the National Academy of Design in 1936. The example at Brookgreen, cast in aluminum instead of bronze, is the only other casting. It was acquired in 1936 and was placed in a small pool in the upper right wing of the gardens.

Heinz Warneke's small *Colt*, measuring 3 1/4-inches-by-6 7/8-inches-by-5-inches, was cast in brass in rough form then carved while he was working in Paris in 1928. Warneke was known as a direct stone carver who worked by carving directly into the stone without making a preliminary model. *Colt* was purchased by the Huntingtons in 1936 and was placed in the Gallery of Small Sculpture in 1937.

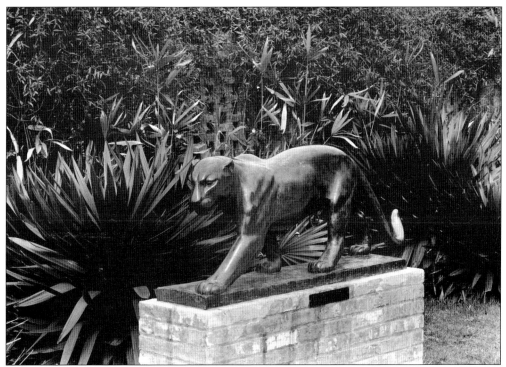

One of a pair of sleek *Black Panthers* by Wheeler Williams is shown in this photograph from the late 1930s. They were modeled at Williams's studio in Hollywood, California, in 1933. He specified an unusual patina—oxidized silver-plated bronze—so the surface of the sculpture would be dark and opaque, and the cat's eyes were lacquered green. The pair was acquired in 1935 and was placed behind the Diana Pool near the entrance gate to the Live Oak Allée in 1936.

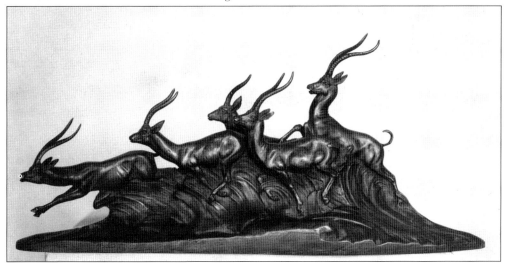

Anna Hyatt Huntington viewed this photograph when selecting Jack Metcalf's *Gazelles Running* for the Brookgreen collection. Although Metcalf had not formally studied sculpture, he painted and modeled in clay while working as an assistant to Louis Paul Jonas in the Jonas Brothers Studio of taxidermy. Metcalf created *Gazelles Running* in 1929 when he was 19 years old. It was purchased in 1936 and was placed in the Gallery of Small Sculpture in 1937.

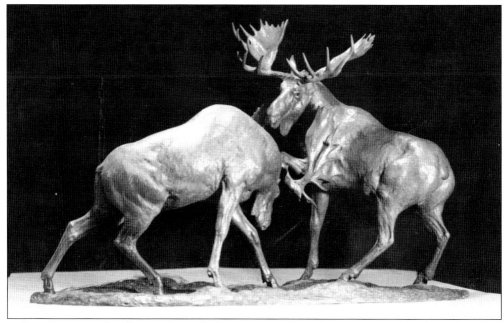

Robert Henry Rockwell came to sculpture through taxidermy, eventually working for several museums, including the American Museum of Natural History. He was chief assistant to Carl Akeley during collecting expeditions for the Akeley African Hall, finishing the project after Akeley's death. *Survival of the Fittest* was modeled in 1938 as a design for a life-sized group of moose in the museum's North American hall. Cast in 1940, it was purchased and placed in that year.

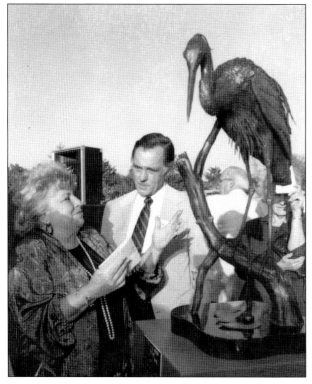

Robert Rockwell retired in 1942 and moved to Virginia's Eastern Shore. Soon after, William H. Turner met Rockwell, helped him in the studio, and eventually was mentored by him. Turner's sculptural focus became native North American wildlife, especially those found near his home on the Chesapeake Bay. In 1988, Brookgreen Gardens acquired Turner's *Great Blue Heron*, and he spoke with Brookgreen member Ann Markiewicz at its dedication reception.

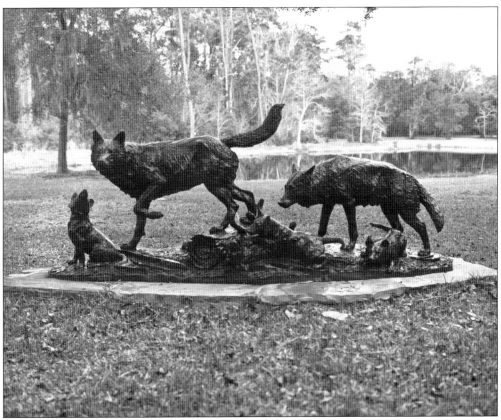

In 1989, William H. Turner was commissioned by the American Museum of Natural History in New York to create a life-size sculpture as a memorial to his mentor, Robert Henry Rockwell. *Timber Wolf Family* was completed and placed there in 1991. Brookgreen Gardens acquired the second casting of the sculpture, the gift of Dorothy R. Blair, in 1992. It was placed in front of Springfield Pond in the Wildlife Park.

African Elephant was modeled by Robert Henry Rockwell in 1935 as a sketch for one of four life-size elephants in taxidermy for the Akeley African Hall of the American Museum of Natural History. He completed the sculpture, cast it, and exhibited it at the National Academy of Design in 1938. It was acquired for Brookgreen Gardens in 1940.

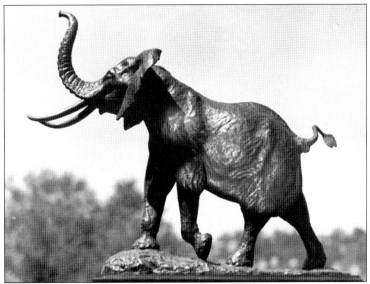

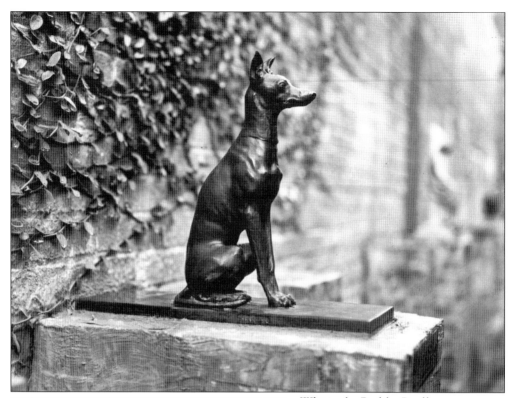

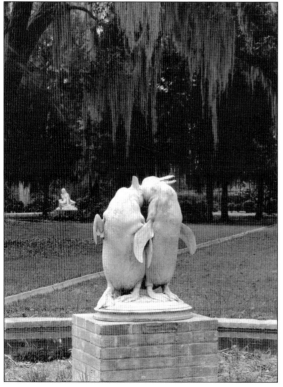

Whippet by Bashka Paeff was a portrait of Scotty, a dog owned by Charles G. Rice of Ipswich, Massachusetts. The sculpture, done in 1919, was to be a surprise Christmas gift, so Mrs. Charles Rice (Anne Proctor Rice) arranged for Scotty to go to the sculptor's studio while her husband was at work. The plaster model was exhibited at the Paris Salon in 1931. *Whippet* was the gift of Samuel M. Waxman and was placed in the Gallery of Small Sculpture in 1961.

Displaying his talent for life-like creations, Albert Laessle's comic *Penguins* was modeled in his Philadelphia studio in 1917. The sculpture received the Widener Gold Medal at the Pennsylvania Academy in 1918 and honorable mention at the Art Institute of Chicago in 1920. The bronze sculpture was acquired for Brookgreen in 1936 and was placed in a pool in the lower right wing of the sculpture gardens in 1937.

One of the famed Piccirilli brothers, Furio Piccirilli, worked in his family's stone-carving firm in the early 20th century. He also created sculpture of his own, including this *Seal*, carved in black marble in 1927. The work was awarded the Speyer Prize of the National Academy in 1929. The Huntingtons acquired the sculpture in 1936 and placed it in a pool in the lower left wing in 1937. Another example of this sculpture is in the Metropolitan Museum of Art in New York.

Although known for Western-themed sculpture, Alexander Phimister Proctor also created numerous animal sculptures. After spending four years in Paris, Proctor worked in New York, where *Trumpeting Elephant* was created in 1908. It was one of several animal sculptures he designed during the period, including a pair of tigers for Princeton University and lions for the McKinley Memorial at Buffalo, New York. *Trumpeting Elephant* was purchased for Brookgreen and was placed in the Gallery of Small Sculpture in 1936.

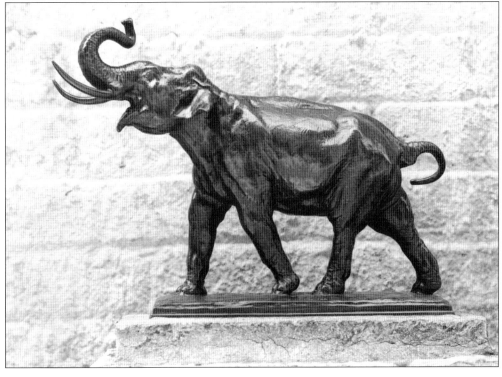

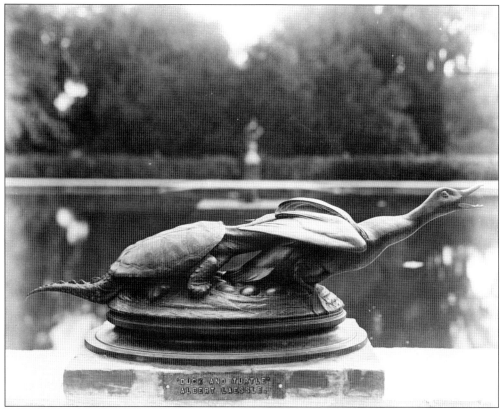

Albert Laessle's *Duck and Turtle* presents predator against prey, a common occurrence in nature. The unfortunate duck has been forced from its nest by a snapping turtle seizing its wing. The sculpture received the McClees Prize of the Pennsylvania Academy in 1928. The Huntingtons acquired the work for Brookgreen in 1936, and it was placed on the edge of the raised pool on the South Carolina Terrace in 1937.

Louis Paul Jonas also began his career as a taxidermist and turned to sculpture. He assisted Carl Akeley at the American Museum of Natural History in New York while he studied at night at the National Academy. After turning away from taxidermy, he began to show his sculpture and to receive commissions. *Jaguar* is the second work by Jonas acquired by the Huntingtons. The statue was purchased and placed in the Gallery of Small Sculpture in 1937.

Giant Sable Antelope was created by Louis Paul Jonas in 1928. Its sleek, art deco design was appropriate to use also as a logo for Jonas's firm, which produced fine art sculpture, dioramas, and animal figures for educational use in schools and museums. *Antelope* was the first of three works by Jonas acquired by the Huntingtons for Brookgreen. It was purchased in 1934 and was placed in the Gallery of Small Sculpture.

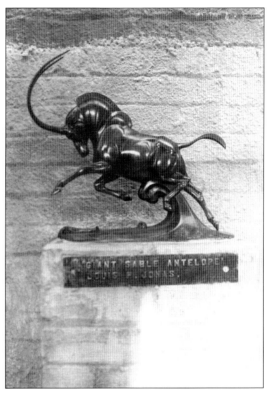

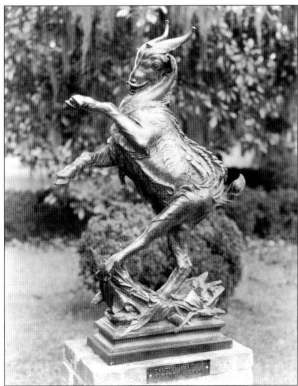

Dancing Goat was one of four sculptures by Albert Laessle acquired for the Brookgreen collection. Created in 1928, the sculpture has human-like attributes with a comically smiling face and high-kicking legs. It was purchased in 1936 and was placed in the center of the gardens near *Dionysus* by Edward McCartan in 1937.

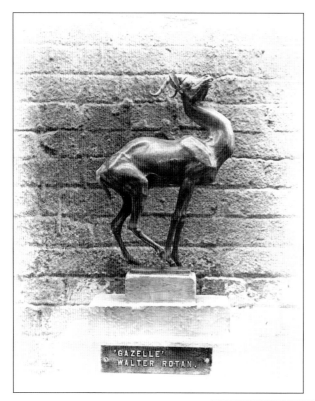

'GAZELLE'
WALTER ROTAN.

Walter Rotan studied at the Maryland Institute of Fine and Applied Arts and later with Albert Laessle at the Pennsylvania Academy. He modeled *Gazelle* at the Philadelphia Zoo early in his career in 1935. Anna Hyatt Huntington was struck by the animal's linear design, acquiring the sculpture and placing it in the Gallery of Small Sculpture in 1936.

Wheeler Williams's *Sea Lion* is one of 10 works by Williams in the Brookgreen collection. Modeled from a famous trained seal named Charlie, the sculpture was designed as a fountain in 1938 for a home in Regent Park, London. The bronze sculpture on a Virginia greenstone base was initially installed in 1951 as a working fountain in a pool in the Brookgreen Zoo. It was the gift of Mrs. E. Gerry Chadwick.

Three

THEMES IN SCULPTURE

The themes of sculpture at Brookgreen Gardens range from Western to mythological, and religious to portraiture. There are themes that focus on childhood, dance, and war, and monuments of significant people in history.

The female figure is frequently portrayed in art. For thousands of years, the feminine form has been the inspiration for sculptures that revered, celebrated, examined, worshipped, and, occasionally, caricatured women, individually and collectively. Brookgreen Gardens is fortunate to have several works that feature goddesses, dancers, adolescents, matrons, and heroines in a variety of poses, everyday activities, and allegorical depictions.

Mythology is another universal theme in sculpture. Brookgreen boasts works featuring deities of ancient Greece, Crete, Rome, and Scandinavia, as well as personages from other cultures. Some of the best-known Western-themed sculptures are found in the Brookgreen collection. Works such as *The End of the Trail* by James Earle Fraser and *The Bronco Buster* by Frederic Remington have become icons of American art and history.

A number of sculptures in the Brookgreen collection began as maquettes or small models for war memorials. In fact, every Memorial Day weekend, flags are placed at sculptures that have patriotic themes, were designed as war memorials, or were created by sculptors who served in the military or in military support jobs during wartime. The quantity is such that a flag can be found next to nearly every outdoor sculpture.

Ernest Wise Keyser studied at the Maryland Institute, at the Art Students League with Augustus Saint-Gaudens, and in Paris. For his decorative figures, he adopted a stylized method reminiscent of archaic sculpture. *Meditation* was acquired in 1932 and was placed in a raised bed in the upper left wing in 1934. An early version of this sculpture was used as a fountain figure on a patio of a private collection in Long Branch, New Jersey.

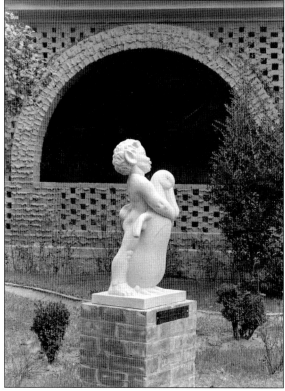

Dorothea Denslow established and operated the Clay Club in 1928, which evolved into the Sculpture Center in New York. Her sculptures for Brookgreen, *Playmates* and *Pelican Rider*, both carved in Tennessee marble, were lighthearted and created for children. *Playmates* (shown at left) and its companion were acquired in 1937 and were placed in front of the Gallery of Small Sculpture in 1938.

Children and Gazelle by Anthony de Francisci was purchased by Anna Hyatt Huntington in 1937, the same year it was created, and was placed in a raised bed in the upper right wing in 1938. The sculpture was mistakenly labeled *Boys and Gazelle* before the staff at Brookgreen looked more closely and realized the error.

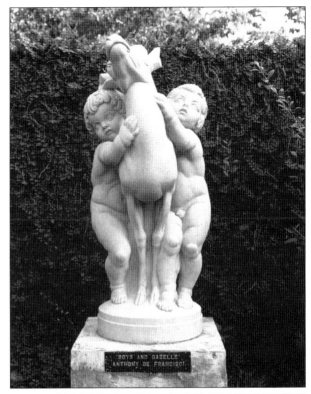

Embodying tranquil repose, *Dream* by Joseph Nicolosi depicts a sleeping young girl and a fawn. When it was acquired in 1937, the work was first placed in a raised bed in the upper right wing. After the Dogwood Garden was completed in 1945, it was moved there and placed in one of the rectangular pools.

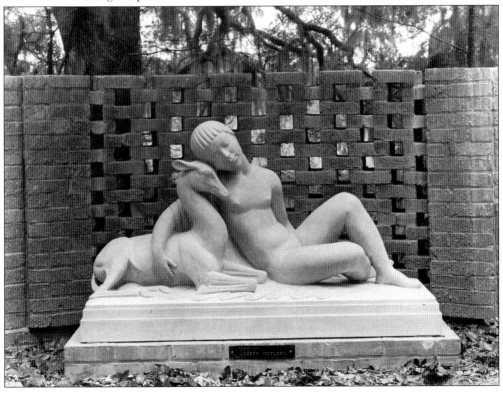

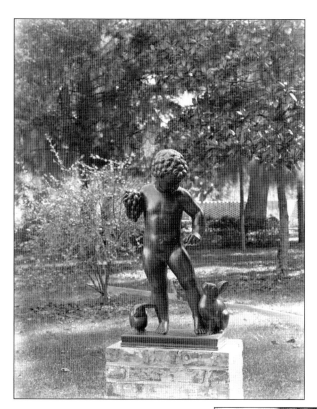

Baby and Rabbits by Albert Stewart was one of a group of sculptures focusing on the theme of childhood that was acquired for the Baby Garden, located in front of the Gallery of Small Sculpture. Also known as *Little Bacchante*, this sculpture was purchased in 1936 and was placed in 1937.

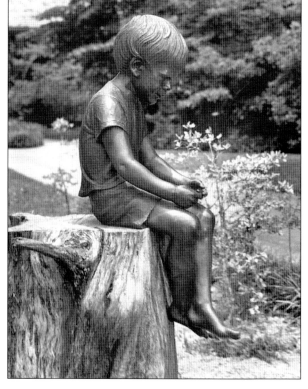

Originally a commissioned portrait, *Long Long Thoughts* by Charles Parks won the gold medal of the American Artists Professional League in 1971. The title was taken from lines by Longfellow: "A boy's will is the wind's will, and the thoughts of youth are long, long thoughts." It was acquired in 1980 and was placed on a cypress stump in the Baby Garden.

Water Buckaroo by Joseph Bailey Ellis depicts a child's fanciful ride on a sea creature. It was inspired by the sculptor's memory of his baby daughter seated in a bird bath. The sculpture was donated by Mrs. Joseph Bailey Ellis (Christine Bullard Ellis) in 1953 and was installed as a fountain in the new Palmetto Garden.

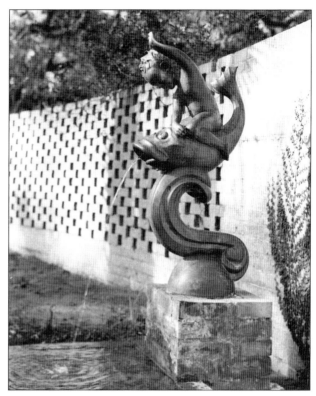

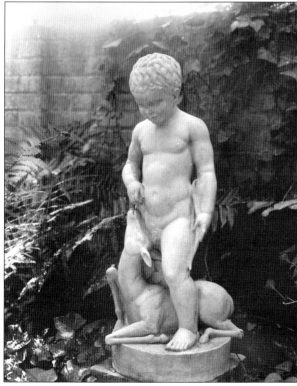

Boy and Fawn by Gaetano Cecere is one of two sculptures by the artist in the Brookgreen collection. The work was created in 1929 and immediately won a Garden Club of America Prize in that year. In 1930, the sculpture was awarded the McClees Prize for the most meritorious sculpture in the Pennsylvania Academy exhibition. *Boy and Fawn* was purchased in 1932 by the Huntingtons and was placed in a raised bed on the Live Oak Allée in 1934.

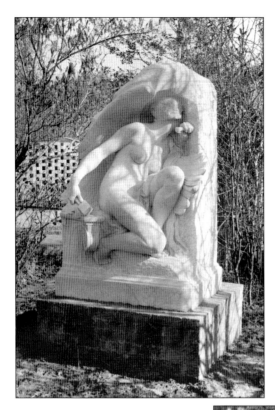

Hermon Atkins MacNeil's enigmatic *Into the Unknown*, also known as *Inspiration*, was first exhibited at the National Academy in 1912. Symbolizing the mystery of artistic creation, the design was adapted as an emblem for the National Sculpture Society in 1923. It was acquired for Brookgreen in 1948 and was placed in the upper right wing of the sculpture gardens.

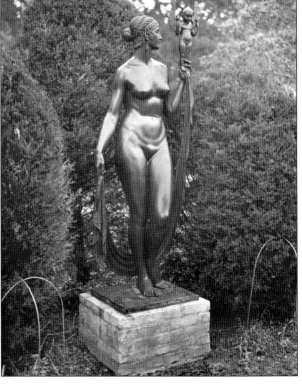

Inspiration and its companion, *Wisdom*, both by Edward Field Sanford Jr., were commissioned in 1928 by the State of California for its capitol building in Sacramento. This casting of *Inspiration*, authorized by the State of California, was acquired by the Huntingtons in 1946 and was placed in the center of the gardens in that same year.

Maidenhood by Sherry Edmundson Fry was modeled in 1914 and was awarded a silver medal at the Panama-Pacific Exposition in San Francisco in 1915. The first casting was sold to Walter B. James for his New York residence. The border pattern of linked snakes on the figure's robe relates her to Hygeia, the Greek goddess of health. The Huntingtons acquired *Maidenhood* in 1936 and placed it in front of the Bird Tower in 1937.

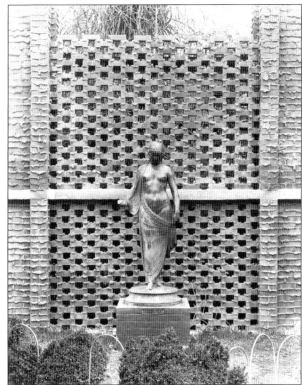

Young America by Joseph Walter was done in the 1940s and was shown at the Metropolitan Museum of Art in New York. Also known as *Retrospective*, the allegorical figure symbolized the spirit of American youth at the time. The work was acquired by Brookgreen Gardens in 1990, the gift of Mrs. Joseph Walter (Berthatt Walter), and initially was placed in a raised bed around the central pool of the new garden area exhibiting *The Fountain of the Muses* by Carl Milles.

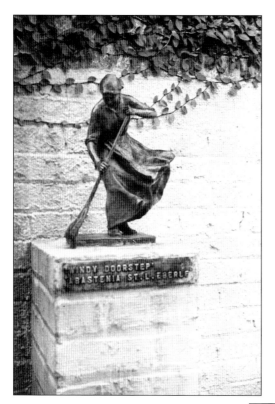

Abastenia Eberle's *The Windy Doorstep* is an important example of the artist's groundbreaking work in the field of genre sculpture. She specialized in sculpting scenes from everyday life, especially immigrants on New York City's Lower East Side and farm women near Woodstock, New York. *The Windy Doorstep*, done in 1910, was acquired by Anna Hyatt Huntington in 1932 and was placed in the Gallery of Small Sculpture in 1934.

William Zorach created *Builders of the Future* for the 1939 New York World's Fair. Symbolizing the slogan of the fair, "Building the World of Tomorrow", the sculpture includes workers, builders, pioneers, and horses depicting the importance of manual labor in the development of civilization and the character, stamina, and determination of the American people. This quarter-size model of the heroic plaster, the gift of William N. Bloom, was acquired by Brookgreen Gardens in 1982 and was placed in the Arboretum.

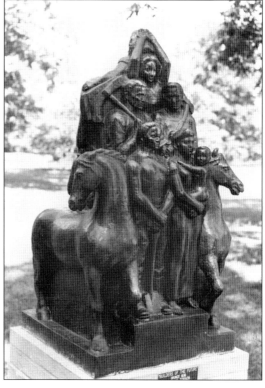

Shark Diver by Frank Eliscu portrays an underwater diver grasping the fin of a shark as both swim through a sea plant. Eliscu wrote, "Only within the suspension of water can the human form be released to its ultimate flow of grace and action." The sculpture was acquired by Anna Hyatt Huntington in 1954 and was placed in the upper left wing in 1955.

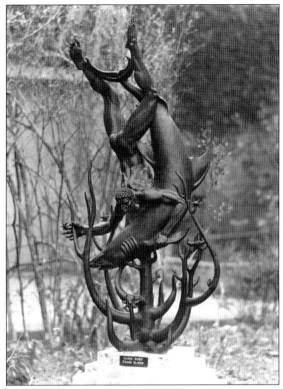

Len Ganeway, Derek Wernher's portrayal of a farmer seated on a park bench reading a newspaper, was commissioned in 1980 by the publisher of the *Lapeer County Press* in Lapeer, Michigan. Wernher's design aptly embodied the subscribers of the newspaper in a hard-working, agricultural community. It was acquired by Brookgreen Gardens in 1985, the gift of Robert and Lura Myers, and originally was placed along the sidewalk between the Visitors Pavilion and the Arboretum.

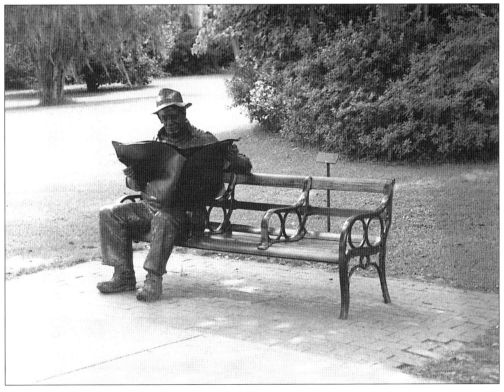

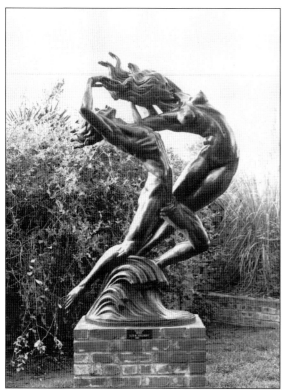

Gleb Derujinsky was commissioned by the Huntingtons to create two sculptures for Brookgreen. The first was *Samson and the Lion*, carved in limestone in 1949. The second commission was *Ecstasy*, two nude figures, male and female, leaping in wild abandon. The exaggerated movements suggested a wave-like motion. *Ecstasy* was created in 1953, cast in bronze, and placed in the Palmetto Garden in 1954.

Walter Rotan preferred to work in small size so that he could retain full control over the final product. *Reclining Woman and Gazelle* is one of only a few large works by Rotan. At the Huntingtons' request, the sculpture was enlarged, modeled, and carved during the winter of 1936 and 1937 from a study made in 1935. Although the sculpture was acquired in 1937, it was not placed until 1941, when the work went into the new Dogwood Garden.

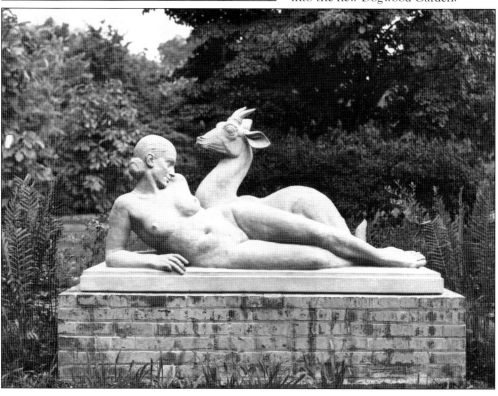

The concept of man struggling to create something of himself was recreated in several sculptures by Albin Polášek. This final and most refined version of the theme shows a powerful male figure carving himself out of a block of stone, his muscles tensed and flexed in exertion. *Man Carving His Own Destiny* was carved in limestone at Brookgreen in 1961 by Robert Baillie and Arthur Lorenzani from Polášek's original model and was placed in a pool in the upper left wing in 1962.

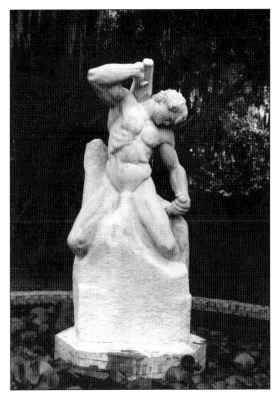

Vincent Glinsky carved directly in stone without referring to a model or design. *Awakening*, first carved in small size in 1930, was widely exhibited, winning the Widener Gold Medal in 1936. The Huntingtons ordered a larger version carved in Tennessee marble for Brookgreen in 1946. It was exhibited in 1948 at the Pennsylvania Academy, winning the Dr. Herbert M. Howe Memorial Prize, and was placed in the new Palmetto Garden in 1950.

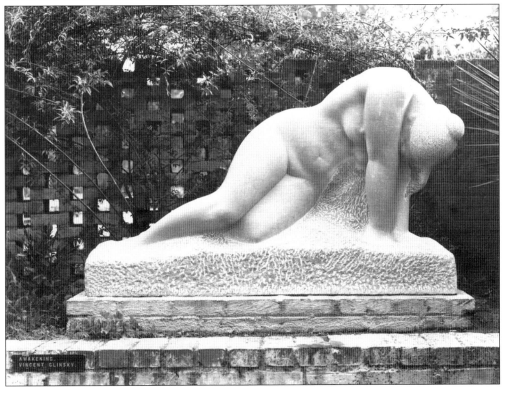

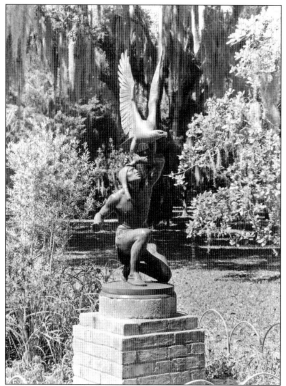

Indian and Eagle by Carl Paul Jennewein is one of several sculptures in the collection originally designed as war memorials. The Native American releasing a bald eagle was the theme of a World War I memorial for American soldiers completed in 1929 and placed at Tours, France. The study model was acquired by the Huntingtons in 1932 and was placed in the center of the gardens in 1934.

Albino Manca's concept of a bald eagle placing a wreath upon the waves was embodied in *Diving Eagle*, the World War II, East Coast memorial to those who died in the Atlantic. The heroic-size bronze, created in 1961, was placed in Battery Park, New York, in 1963. The version at Brookgreen is the first enlargement. It was acquired in 1981 and initially was placed on a tiered brick pedestal in a traffic island on the entrance road.

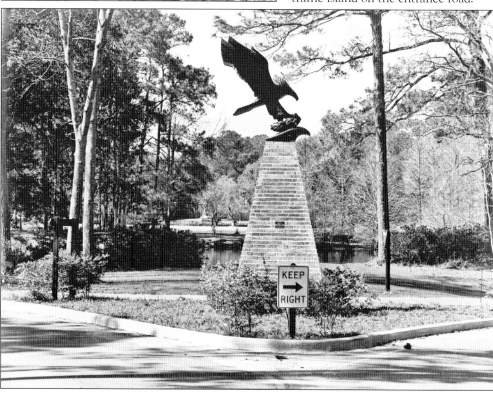

Daniel Chester French's powerful statement on war, *Disarmament*, was created for temporary placement on the Victory Arch, which was erected in New York City in celebration of the armistice of World War I. The small child gazing up in supplication at the powerful warrior has touched hearts since it was created in 1919. The work was acquired by Anna Hyatt Huntington in 1950 and was placed in a raised bed in the new Palmetto Garden.

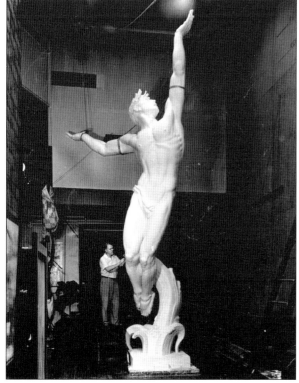

The 22-foot-tall version of *Spirit of American Youth* (also known as *Life Eternal*), the D-Day memorial by Donald De Lue, was placed at the American Cemetery at St. Laurent-sur-Mer in Normandy, France, in 1956. Here De Lue works on the full-scale plaster model. Brookgreen Gardens acquired the half-size model for this sculpture in 1981 and placed it on the walkway between the sculpture garden parking lot and the visitors pavilion.

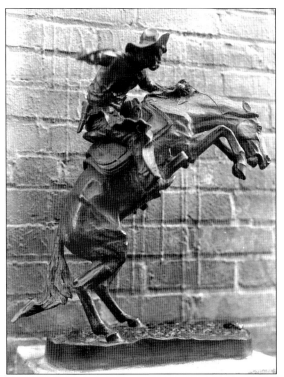

Themes from the Wild West attracted the public in the late 19th and early 20th centuries. No sculpture was more popular than *The Bronco Buster* by Frederic Remington. Created in 1895, it was Remington's first attempt at sculpting, although he was well known for his drawings and paintings of Western scenes. Archer Huntington purchased it from a private collection for Brookgreen in 1936 and placed the work in the Gallery of Small Sculpture in 1937.

The End of the Trail by James Earle Fraser, modeled in 1915, was intended to be an allegorical sculpture inspired by the writings of Marion Manville Pope, but it is often interpreted as a symbol of the decline of the Native American way of life. The sculpture was acquired in 1932, placed on the edge of the rice fields in 1934, and later moved to other locations in the gardens.

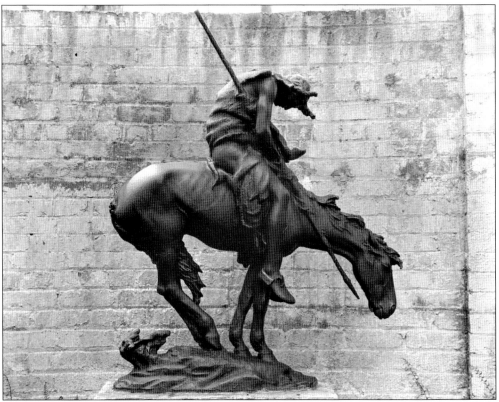

The Sun Vow by Hermon A. MacNeil, from 1899, came at the height of popularity for Native American subjects. MacNeil's romantic interpretation of a Sioux rite of passage attracted attention. The older Native American supervises the young boy shooting an arrow, looking into the sun. If his aim is true, the arrow disappears from sight and the boy becomes a warrior. The Huntingtons acquired the sculpture in 1932, and it was placed in the upper right wing in 1934.

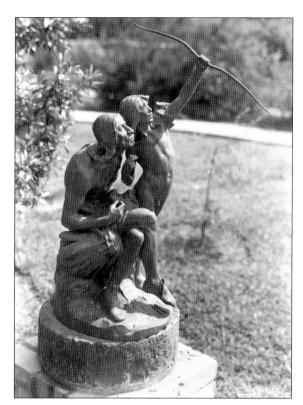

Alexander Phimister Proctor's *Pursued* depicts a Native American on horseback fleeing from an unseen enemy. Spending many years in the American West, Proctor preferred to interpret scenes of action and movement in his sculpture. *Pursued* was acquired by the Huntingtons in 1932 and was placed in the Gallery of Small Sculpture in 1934.

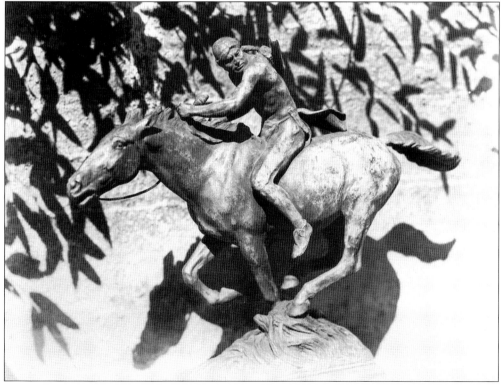

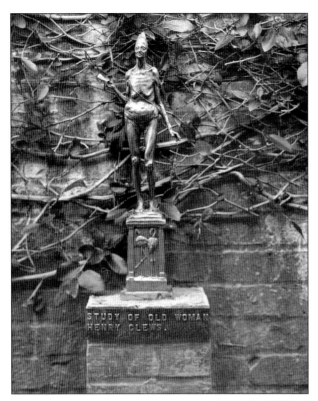

Henry Clews's individual sculptural interpretation often focused on the evils of American society in the late 19th and early 20th centuries. *The Duchess* presents a satirical view of a haughty old woman with a fan and headdress, wearing pearls over sagging and wrinkled skin. Stripped bare, there is no substance beneath her finery. The sculpture was cast in aluminum and was placed in the Gallery of Small Sculpture in 1952.

Henry Clews and Archer Huntington knew one another and exchanged correspondence until Clews's death in 1937. Shortly after his widow established the Henry Clews Foundation, the Huntingtons acquired four of his sculptures. The idea of man's lifelong search for truth was pursued by Henry Clews in small studies such as this. Cast in aluminum and placed in the Gallery of Small Sculpture in 1952, the work was later stolen.

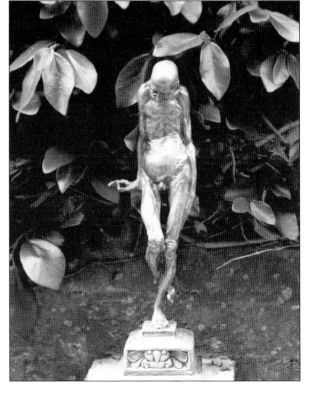

Made of aluminum, *The Thinker* by Henry Clews sits on its bronze base at the Roman Bronze Works in Corona, New York, after being cast in 1949. The figure was created in Paris in 1914, and the base was modeled later at Clews's home, La Napoule, near Cannes, France. Visible are (left) part of the plaster model for Anna Hyatt Huntington's *Don Quixote* and (far right) part of the small model of her *Fighting Stallions*.

Considered Henry Clews's masterpiece, *The Thinker* requires the appreciation of art interpretation. In it, Clews expressed his perceived distaste for the shallow commercialism of American culture and basic evils in education, government, religion, war, and family life. Until recent years, the example at Brookgreen, acquired and placed in 1952, was the only casting. It is shown in its original location in a pool on the edge of the Arboretum.

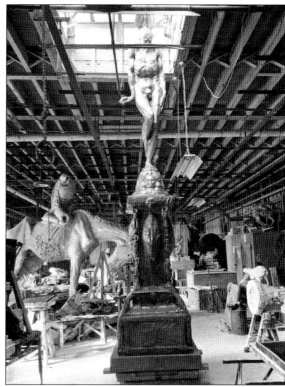

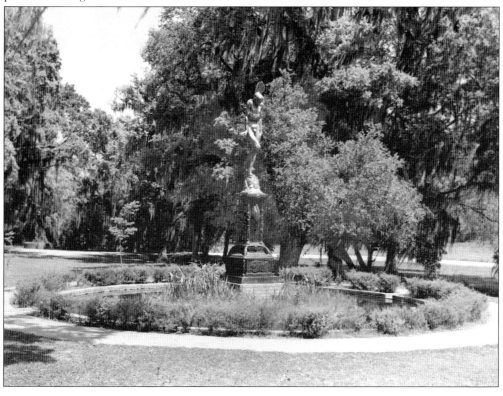

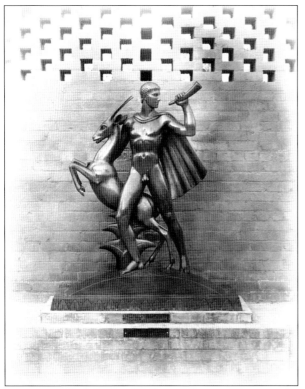

The Hunt by Eugene Schoonmaker (also known as *Actaeon*) represents the unfortunate hunter who surprised Diana, goddess of the hunt, while she bathed in a woodland pool. *The Hunt* was acquired by the Huntingtons in 1936, and although it was over 4-feet high, it was placed on the back wall of the Gallery of Small Sculpture in 1937.

Themes from mythology abound at Brookgreen Gardens. *Orpheus* by John Gregory depicts the Greek god whose music charmed wild animals. The sculpture was enlarged in 1941 from an earlier version, also in the collection of Brookgreen Gardens. The large version was acquired and placed in the Dogwood Garden in 1942.

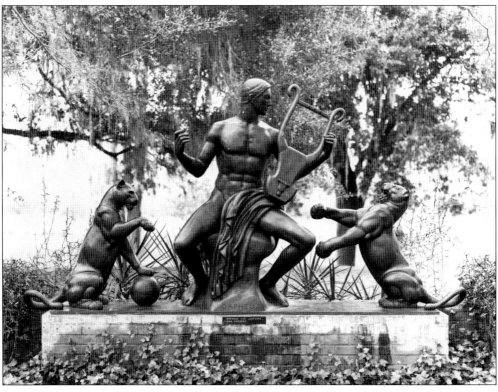

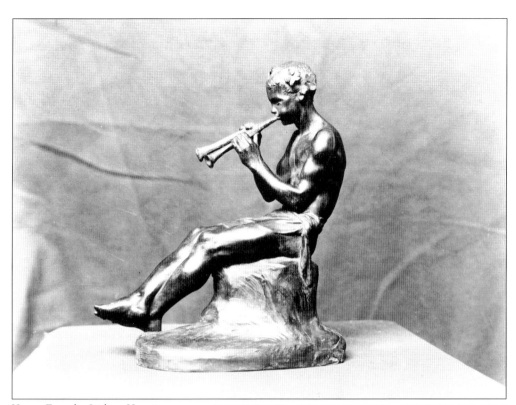

Young Faun by Isidore Konti
showcases the sculptor's ability in
decorative work. It is reminiscent of
Renaissance art that Konti viewed
in Italy when he lived in Rome
from 1886 to 1888. *Young Faun*
was acquired by the Huntingtons
in 1936 and was placed in the
Gallery of Small Sculpture in 1937.

Iris, goddess of the rainbow and
messenger to the gods, was created
by Carl Paul Jennewein in 1939.
It was cast in two sizes in 1941,
and the Huntingtons acquired the
smaller version in 1943. Despite
critical acclaim, the over-life-size,
burnished bronze version remained
in Jennewein's studio until 1978,
when he donated the work to
Brookgreen, and the sculpture
was placed in the Jennewein
Gallery of the Visitors Pavilion.

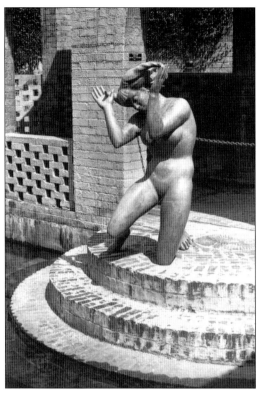

Persephone, goddess of spring and queen of the underworld, is depicted here as the harbinger of spring. Created by Marshall Fredericks in 1972, *Persephone* illustrates the moment at which the goddess of spring ascends from the underworld to Earth, bringing with her the advent of spring. The work was acquired in 1981 and initially was placed on the steps at the pool in the front area of the Gallery of Small Sculpture.

Joseph Emile Renier's *Pomona* depicts the goddess of fruit and fruit trees with lush proportions and a basket of fruit to her side. The design was created in 1929, and the full-size sculpture was carved in Tennessee marble for Brookgreen in 1937. It was placed in one of the rectangular pools in the Dogwood Garden in 1941.

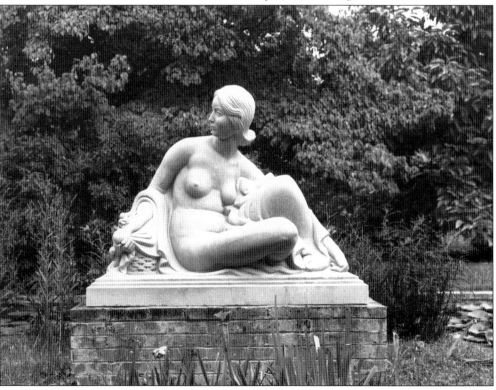

Phryne Before the Judges by Albert Wein portrays the moment when the Greek courtesan Phryne removes her cloak to display her beautiful body and receive a favorable verdict from the judges. Wein created the sketch model in Rome in 1948. Archer Huntington ordered an over-life-size version that was carved in limestone by Robert Baillie and was placed on the edge of Dogwood Pond in 1952.

The Nereids, in Greek mythology, were friendly sea nymphs, the 50 daughters of Nereus and Doris. Most famous among them was Amphitrite, the wife of Poseidon. Berthold Nebel's *Nereid*, carved in Gris de Alicia marble, was acquired in 1932 and later was placed in a rectangular pool in the Dogwood Garden in 1945.

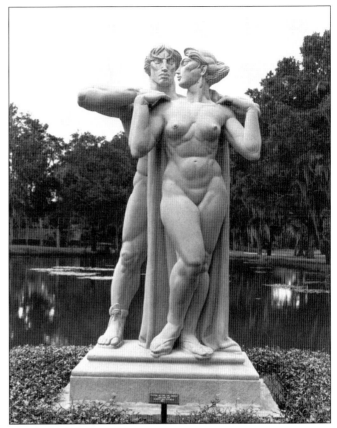

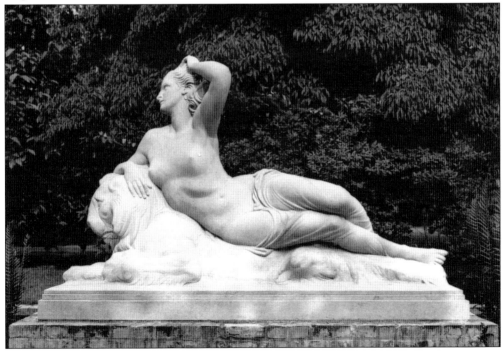

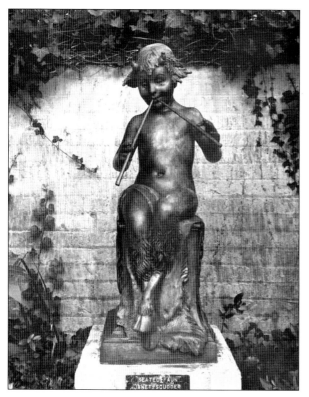

Janet Scudder was the first woman to focus on garden sculpture in the late 19th and early 20th centuries. Her delightful *Seated Faun* depicts a young faun sitting on a bench, draped with a skin, and playing double pipes. Created in 1924 and cast in Paris, it was acquired by the Huntingtons and was placed in the upper right wing in 1940.

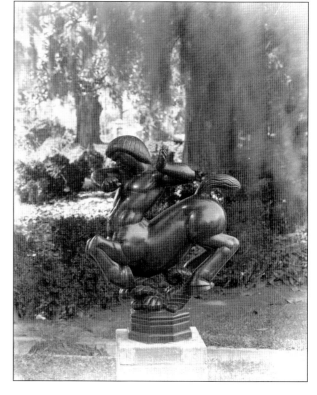

Young Centaur by Albert Stewart depicts a mythical creature, half man–half horse, as a playful child. The sculpture was modeled in 1931 and was awarded the Helen Foster Barnett Prize of the National Academy of Design. *Young Centaur* was acquired for the Baby Garden in 1936 and was placed there in front of the Gallery of Small Sculpture in the same year.

A sculptor of garden figures, monuments, and portraits, Eleanor Mellon was best known for ecclesiastical sculpture. She wrote: "When the artist approaches [this field], his desire is to work to the glory of God with the greatest skill, dedication and devotion." This sculpture is subtitled *Behold Saint Christopher; then shalt thou be safe.* Created in 1967, the work was donated to the Brookgreen collection by the sculptor and was placed adjacent to the raised pool on the South Carolina Terrace.

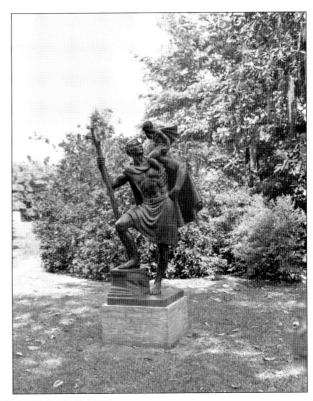

Christ Child was carved while Abram Belskie was employed in the stone-carving studio of Robert Baillie. Belskie's first public sculpture, *Christ Child* was purchased by Archer Huntington for Brookgreen in 1934 and was placed in a raised bed niche in the lower right wing in 1935. The work depicts the child with a cruciform halo behind the head. Stylized symbols of the evangelists fill angles in the design.

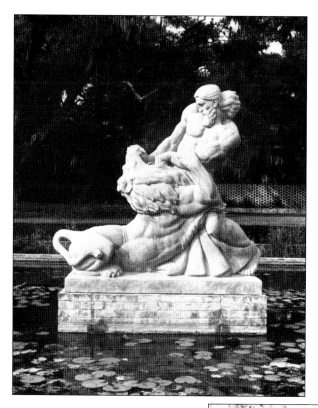

The powerful and dramatic stone carving *Samson and the Lion* by Gleb Derujinsky was the second work by the sculptor acquired for Brookgreen. Commissioned life-size and carved in limestone, it was completed and acquired in 1949 and was placed in 1950 as the focal point in the center of the pool in the Palmetto Garden.

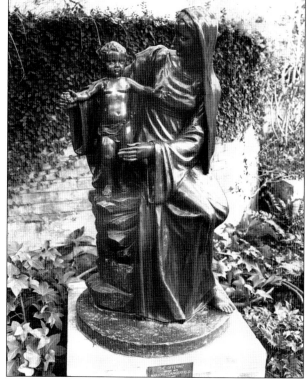

The Offering by Marjorie Daingerfield was the sculptor's last major work. It depicts the Virgin Mary seated with the Christ child standing next to her, arms extended in blessing. The bronze sculpture was designed in 1972 for the Mary Garden of the Episcopal Church of St. Mary's of the Hills in Blowing Rock, North Carolina. This, the only other casting, was given to Brookgreen Gardens by Joseph D. Dulaney and Elliott D. Dulaney in 1985.

Four

WOMEN SCULPTORS

In 1992, Brookgreen Gardens was designated a National Historic Landmark due to the significance of Anna Hyatt Huntington's career as an artist and as an important patron of the arts. The National Historic Landmark designation also recognized the large number of women sculptors represented in the collection, affirming Brookgreen Gardens' existence as an important historical site for American women artists, and for the study of the roles and contributions of American women in general.

Anna Hyatt Huntington's status as a major sculptor of animals and of equestrian monuments was sealed before 1914. Her *Reaching Jaguar* and *Jaguar* achieved critical success at the Paris Salon in 1908, and her first version of *Joan of Arc* won an honorable mention at the Paris Salon in 1910. Her major commission for a second version of *Joan of Arc*, placed at Riverside Drive and Ninety-third Street in New York City, catapulted her into the international spotlight as dignitaries from the United States and France watched while Mina Edison, Thomas Edison's second wife, unveiled the sculpture in 1915.

Some artists, such as Harriet Frishmuth and Sally James Farnham, specialized in portraying the female form, often using dancers as models. Evelyn Longman and Elsie Ward Hering sometimes focused on the depiction of women as deities or embodiments of human goals and aspirations. Others, including Bessie Potter Vonnoh, Abastenia Eberle, and Glenna Goodacre, simply presented women in their daily roles and provided historical and cultural contexts for women at specific time periods. Malvina Hoffman worked on a massive commission over several years to depict the various races of the world for the Field Museum of Natural History. In the exhibit the Races of Man, more than 100 heads, busts, and full figures cast in bronze and carved in stone were shown to the public.

At the time of the National Historic Landmark designation, women sculptors represented approximately one-fourth of the Brookgreen collection. Today there are more than 100 female artists in the collection, as this significant area is continually built upon and strengthened.

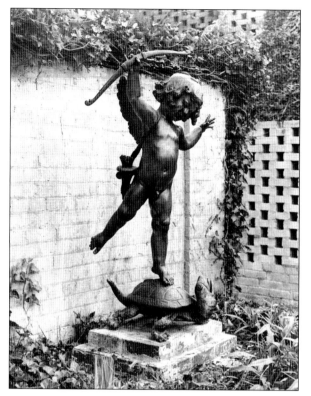

Janet Scudder worked with Frederick MacMonnies, and on a trip to Italy in 1908, she saw for the first time the Renaissance sculpture that became a pivotal influence in her work. With the patronage of architect Stanford White, Scudder's career was firmly established, and her work was bought as quickly as she could produce it. *Tortoise Fountain* was created when she was first inspired in Italy. The work was acquired in 1950 and was placed in a raised bed in the upper right wing.

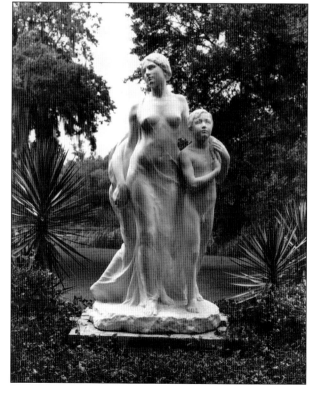

Edith Howland created garden sculpture as well as smaller figures and heads. *Between Yesterday and Tomorrow* was done in 1913 when the sculptor was living in France. Inspired by a Spanish gypsy song, "I move like a prisoner caught, for behind me comes my shadow, and before me goes my thought," the sculpture represents three stages of life. The work was acquired in 1940, the gift of the sculptor, and was placed in the Dogwood Garden.

In 1930, Malvina Hoffman was an established sculptor when she received a major commission from the Field Museum of Chicago to travel the world and model racial types. During a five-year period, she produced more than 100 heads, busts, and full figures that culminated in an exhibition the Races of Man. *Bali Dancer*, modeled in Den Pasar in 1932, was acquired for Brookgreen in 1936, and was placed in the Gallery of Small Sculpture in 1937.

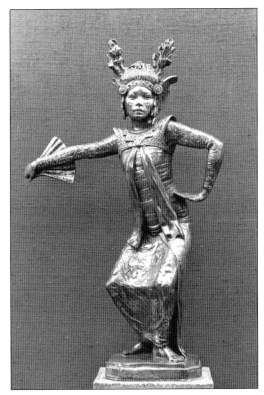

Laura Gardin Fraser studied with James Earle Fraser and later married him. She was commissioned in 1946 to create *Pegasus*, the largest sculpture in the collection. She completed the model in 1951 and delivered it to the Mt. Airy, North Carolina, granite quarry, where stone carver Edward Ratti roughed out four separate blocks. The blocks were shipped to Brookgreen, set up next to the full-scale plaster model, and carved in place through late 1954.

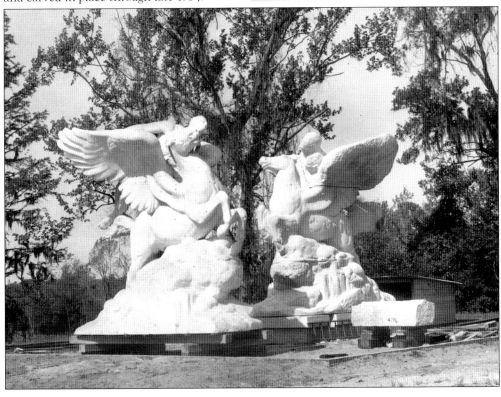

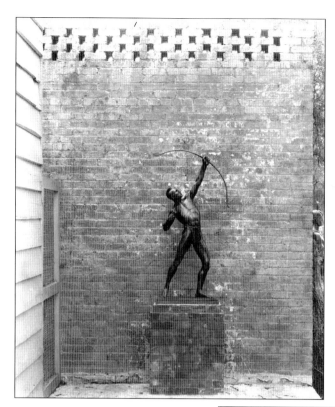

Texas sculptor Allie Victoria Tennant was commissioned in 1936 to create a heroic figure for the Hall of State, a permanent building at the Texas Centennial Exposition in Dallas. For her subject, she chose the state's namesake—the friendly Tejas tribe. The study model of *Archer-Tejas Warrior* was acquired by the Huntingtons in 1936, with special permission from the state of Texas, and was placed on the Old Kitchen Terrace in 1937.

Eugenie Shonnard studied with James Earle Fraser and had criticisms from Bourdelle and Rodin. Although she also modeled human figures, her animal subjects were her finest works. *Marabou*, carved in Napoleon gray marble, was designed as early as 1915, when she created a pair to use as gateposts. The work was acquired for Brookgreen in 1936 and was placed at the entrance to the service building in the upper left wing in 1937.

Hope Yandell, a great-niece of sculptor Enid Yandell, was encouraged to develop her artistic talent. After studying at the Maryland Institute, she attended the National Academy School where her teachers were Albert Wein, Ruth Nickerson, and Bruno Lucchesi. *Lioness and Cub*, her first major commission, was designed in 1981 for a specific setting on a Florida estate. In 1986, the sculptor donated it to Brookgreen in honor of Margaret Mason Peabody. Placed in 1987, the base was installed by stone masons under Yandell's supervision.

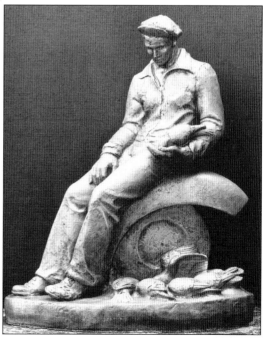

Ethel Painter Hood had eclectic career pursuits as a marathon swimmer, writer, musician, and painter before becoming a sculptor. *Saint Francis of the Curbs* was begun in 1945 when Hood saw a truck driver feeding pigeons and noticed the contrast between his outwardly rough appearance and gentle manner. It was completed in 1947, cast in aluminum at the request of Anna Hyatt Huntington, and placed in the Gallery of Small Sculpture.

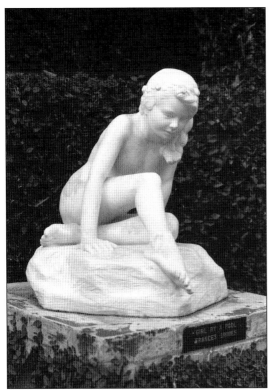

Frances Grimes was an assistant in the studios of Herbert Adams and August Saint-Gaudens. In her independent work, focusing on portraits and images of children, she created bas-reliefs and fountain figures. *Girl by a Pool* was designed in 1913, and a small bronze was cast. The work was enlarged and ordered in stone by Anna Hyatt Huntington for Brookgreen in 1936 and was placed in a niche in a raised bed in the lower right wing.

The charming bronze *Boy and Frog* by Elsie Ward Hering was acquired in 1932 and was placed at the edge of the pool at the right front of the Live Oak Allée in 1934. Hering studied with Augustus Saint-Gaudens, Daniel Chester French, and Siddons Mowbray before going to Paris in 1898, where this sculpture was modeled. She later worked as an assistant to Saint-Gaudens and with her husband, Henry Hering, until her untimely death in 1923.

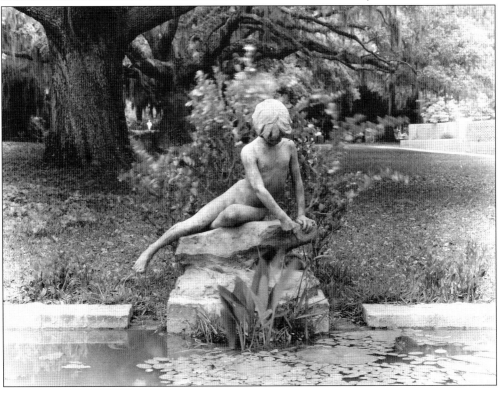

Janet de Coux apprenticed with several sculptors, including Paul Jennewein, Alvin Meyer, Gozo Kawamura, and James Earle Fraser. Although her first works were decorative figures, she eventually focused on biblical characters as subjects, bringing out their human qualities in the designs. Her depictions of *Adam* and *Eve* as infants were created in 1930. They were acquired in 1936 and placed as gateposts on steps leading to the old rice fields in 1937.

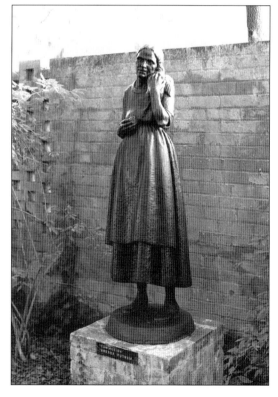

Brenda Putnam began her career creating fountain figures and engaging portraits of children. Later her style shifted toward a plainer and more somber presentation that evoked dignity without sacrificing the tenderness found in her earlier work. An example from the later period is *Communion*, dating from 1939, a portrait of Mary Baillie, mother of Robert Baillie. *Communion* was acquired and placed in the Dogwood Garden in 1941.

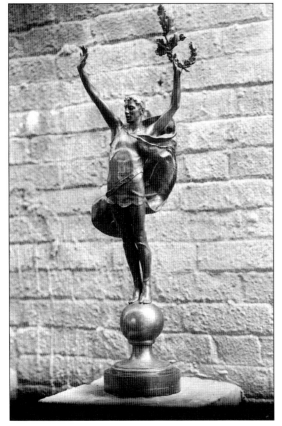

The inspiration of Veryl Goodnight's *Cares for Her Brothers* was a Cheyenne tale about Ewo-Wumishi-He-Me, a woman who loved and cared for all living things. The sculpture depicts a pioneer woman protectively cradling a mule deer fawn. *Cares for Her Brothers* was acquired in 1987, the gift of Wynant J. Williams, and was placed adjacent to Dogwood Pond in the same year. Brookgreen members attended its dedication at the spring reception in 1987.

Evelyn Longman was the only woman admitted as an assistant in Daniel Chester French's studio. After three years, she opened her own studio, but her connection with French grew into a lifelong friendship. Her professional debut as a sculptor was with *Victory*, designed for the dome of the Festival Hall at the 1904 Saint Louis Exposition. A reduction, made in 1908 from the study, was acquired by Brookgreen in 1935 and was placed in the Gallery of Small Sculpture in 1936.

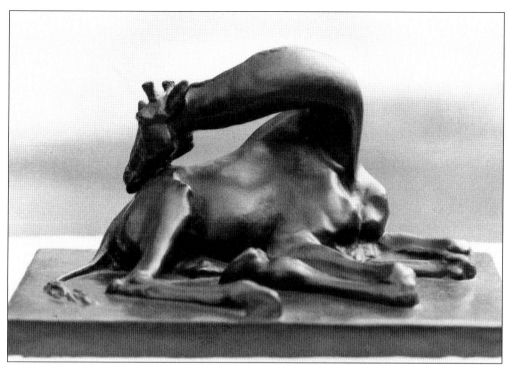

Madeleine Park modeled animals from life at the circus, rodeo, and zoo. She studied at the Art Students' League in New York City, but marriage and children brought a temporary halt to her career. Later she again showed her artwork, won awards, and gained recognition. *Sleeping Giraffe* (also titled *Ringling's Lying Down Giraffe*), designed prior to 1950, is one of many studies of a circus animal. The sculpture was acquired in 1988, the gift of H. Halsted Park Jr., and was placed in the Jennewein Gallery.

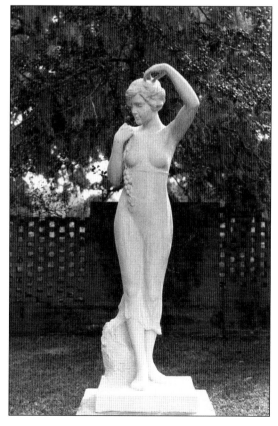

Clio Hinton Bracken's mother was a sculptor and painter, as was her cousin, Roland Hinton Perry, with whom she shared a studio. Trained in New York and Paris, Bracken focused on dance, allegory, and mythology as subjects. A small model of *Chloe*, representing the patroness of verdure, was done in the early 20th century, then enlarged and cut in marble 20 years later. *Chloe* was acquired in 1953, the gift of Robert Baillie, and was placed near the Dogwood Pond.

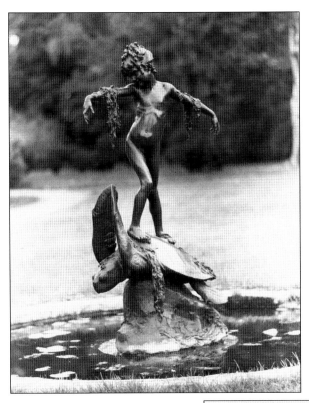

Philadelphia native Beatrice Fenton was encouraged by artist Thomas Eakins, a family friend. Her principal works were fanciful and lively fountain figures, such as *Seaweed Fountain*, created in 1920 and placed in Fairmount Park in 1922. Another casting was acquired by Anna Hyatt Huntington in 1932 and was placed in a pool in the upper right wing in 1934.

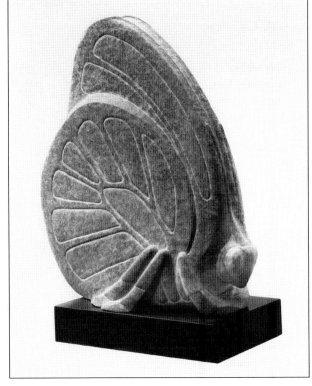

Cleo Hartwig, a direct stone carver, was married to sculptor Vincent Glinsky. Her early work was characterized by simple, compact forms and precisely patterned detail. In later work, she carried abstraction as far as recognition of the subject permitted. *Resting Butterfly*, carved in Serpentine stone in 1979, was acquired in 1980, the gift of Joyce and Elliot Liskin, and was placed in the Jennewein Gallery. The veining patterns on the wings suggest that of a Monarch butterfly.

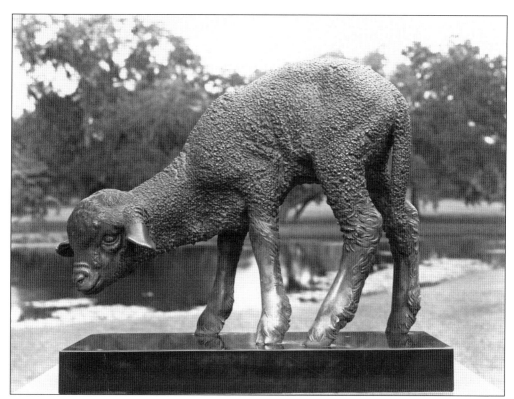

Gertrude Lathrop, a sculptor of animals, shared a studio with her mother, a painter, and her sister, a writer and illustrator. Working until the age of 90, she continued to receive awards well into her later years. *Little Lamb*, created in 1936, received the Speyer Prize of the National Academy in that year, and the Crowninshield Prize of the Stockbridge Art Exhibition in 1937. Cast in silver-plated bronze, *Little Lamb* was acquired in 1972 and was placed in the Jennewein Gallery in 1973.

Initially encouraged by Anna Hyatt Huntington, Sylvia Shaw Judson created quietly beautiful sculpture reflecting her Quaker beliefs. *Girl with Squirrel*, designed as a memorial for Kosciusko Park in Milwaukee, Wisconsin, was acquired for Brookgreen in 1936. The work was placed first in the sculpture gardens and then was moved to the Gallery of Small Sculpture.

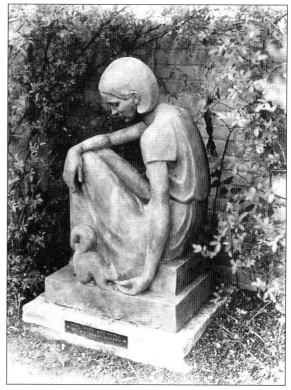

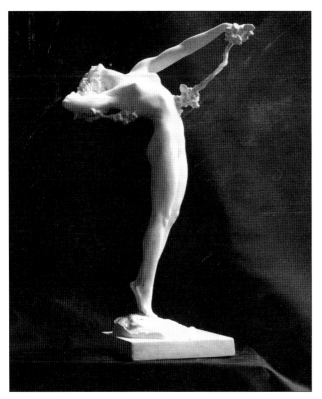

Known as the "lyrical sculptor", Harriet Frishmuth imbued her works with such spirit and joie de vivre that her sculpture immediately became popular in the early 20th century and was acquired by numerous clients for estate gardens. Using dancers as models, Frishmuth focused on the beautiful line and composition inherent in dance moves. The Huntingtons acquired the small version of *The Vine*, created in 1921, and placed it in the Gallery of Small Sculpture in 1935.

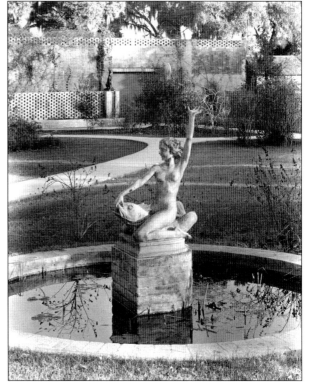

Harriet Frishmuth's tendency to utilize poses and gestures of uninhibited exuberance and sensuality was characteristic throughout much of her work. *Call of the Sea*, a fountain figure, was created in 1924 and was acquired for Brookgreen in 1935. The work was placed in a pool in the upper left wing in 1936. Visible at the entrance to the service building in the background are (left) *Adonis* by Eli Harvey and (right) *Marabou* by Eugenie Shonnard.

Katharine Lane Weems of Boston visited Anna Hyatt Huntington at her studios in Cambridge, at Annisquam on Cape Ann, and later in New York City. There, Weems found the encouragement that she needed to continue her artistic study and received valuable criticism that helped her grow into an award-winning sculptor of animals. *Doe and Fawn* was created in 1927, acquired by Huntington, and placed in the Gallery of Small Sculpture in 1934.

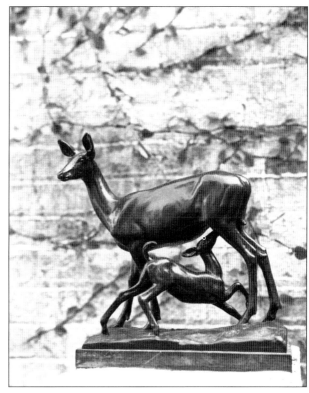

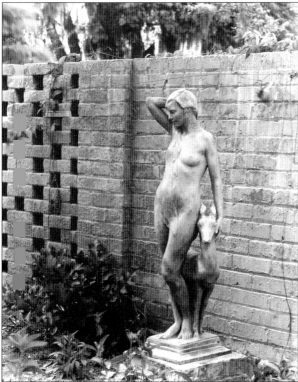

After graduating from Barnard College, Helen Journeay was encouraged by Mahonri Young and studied on her own in Baltimore and in Europe. Anna Hyatt Huntington viewed photographs of *Dawn* by Helen Journeay and, believing it strengthened the composition, suggested the addition of drapery before purchasing the sculpture in 1932. *Dawn* was placed in a raised bed along the Live Oak Allée in 1934.

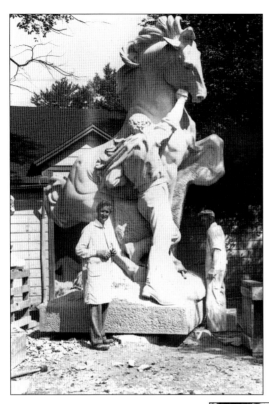

Anna Hyatt Huntington's *Youth Taming the Wild* began as a design made in 1914 for a pair to be used as gateposts. The sculpture was modeled in 1927 and was carved in limestone by Robert Baillie for Brookgreen. The work was placed in a pond on the entrance drive to the sculpture gardens in 1933. It also was adapted as a memorial to her father-in-law, Collis Huntington, at Newport News, Virginia.

In 1953, Archer Huntington asked Anna Hyatt Huntington to create a sculpture that commemorated the founding of Brookgreen Gardens. She designed a cruciform background with the tree of life, native animals, two figures seated in the center, and objects representing their interests on the sides. It was enlarged from her model, carved in limestone by the Robert Baillie firm, and placed in a reflecting pool on-site in 1955. Titled *The Visionaries*, it is shown here nearly completed outside the Baillie Studio in Closter, New Jersey. The section with the human figures was removed in preparation for shipping.

Harriet Hyatt Mayor, Anna Huntington's older sister, was a sculptor as well. She studied with Henry Hudson Kitson in Boston and created garden figures, portraits, and memorial plaques. In 1900, after marriage, her work slowed as she raised a family. *Girl with Fish* was inspired by Rudyard Kipling's character Mowgli. It was acquired for Brookgreen in 1940 and was placed in the Dogwood Garden in 1941.

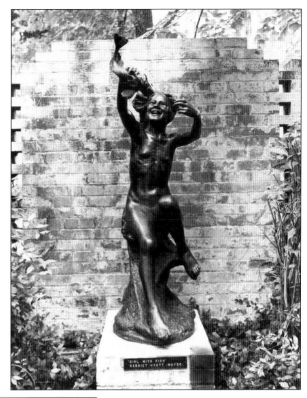

Kristen Lothrop studied sculpture at Bennington College, Corcoran Gallery of Art, and privately in Gloucester, Massachusetts. Katharine Lane Weems gave Lothrop encouragement and advice in her work as a portrait and animal sculptor. *Early Morning Work-Out*, created in 1986, is a portrait of the sculptor's son holding a scull oar and preparing to row in a single shell. Lothrop is pictured with Joseph Veach Noble, Brookgreen's chairman, at the sculpture's dedication in the Small Sculpture Gallery in 1987.

Water Lilies by Bessie Potter Vonnoh was first exhibited in 1913 and won the National Arts Club Prize in 1920. Created for a lily pond, its design is in keeping with the fountain sculptures and groups of children for which she was known. *Water Lilies* was acquired by the Huntingtons and was placed in the Gallery of Small Sculpture in 1934. Also pictured (left) is *Faun* by George Lober.

Brenda Putnam began to create sundials and a series of children in fountains about the time she shared a studio with Anna Hyatt on Twelfth Street in New York City. She also was known for portrait reliefs of children that were commissioned by eager parents. *Sundial* was acquired in 1931 and was placed as the centerpiece in the Baby Garden at the entrance to the Gallery of Small Sculpture in 1934. On the left is *Playmates* by Dorothea Denslow, which was acquired in 1937 and placed in 1938.

Five

THE ART MEDAL

In 1996, Brookgreen received a major gift of art medals comprising the complete series of the Circle of the Friends of the Medallion (1909–1915) and the Society of Medalists (1930–1996). Including more than 150 individual medals, the gift was given by Joseph Veach Noble of Maplewood, New Jersey. An authority on medallic art, Noble oversaw the Brookgreen medal series for many years, serving on the Brookgreen board of trustees from 1971 until his death in 2007 (he was chairman from 1976 to 1995).

In 1973, Brookgreen Gardens launched a membership program that included, as a benefit for upper-level members, the creation of a limited edition, bronze bi-face medal. Each year, America's greatest practitioners in this unique field of sculpture have been commissioned to design the Brookgreen Medal. Beginning with Paul Jennewein, to date 37 illustrious sculptors have created the series of medals that focus on three themes or subject areas: the sculptor at work, the flora and fauna of South Carolina, and the history of the property that comprises Brookgreen Gardens. Each medal is to include the words "Brookgreen Gardens" and "South Carolina" somewhere in the design.

Initially struck in very small quantities, the medal numbers increased as Brookgreen's membership grew. Today a total of 1,000 medals are struck annually and distributed to members of the President's Council, Chairman's Council, and Huntington Society. The Medallic Art Company has been the manufacturer of the Brookgreen Medal series since its inception. This company was established in New York City in 1903, moved to Danbury, Connecticut, and today is located in Dayton, Nevada. Medals from the Brookgreen series are in collections of the Smithsonian Institution, the American Numismatic Society, the National Sculpture Society, the British Museum, and in private collections around the world.

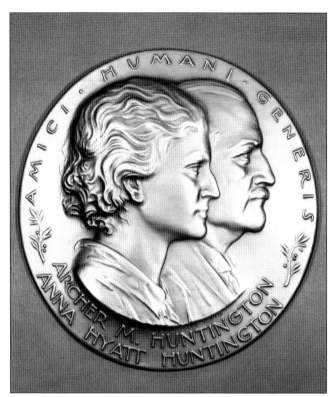

Paul Jennewein designed the *Huntington Medal*, the first in the series of Brookgreen Medals, in 1970. The obverse featured the profile portraits of Anna Hyatt Huntington and Archer Milton Huntington, as they appeared when they founded Brookgreen Gardens. The portraits are framed by the words *Amici, Humani, Generis*, literally meaning friends of the human race, in reference to philanthropy.

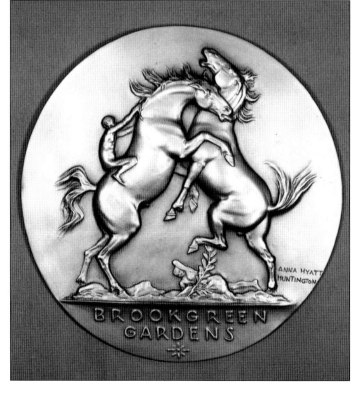

The reverse of the *Huntington Medal* depicted Anna Hyatt Huntington's *Fighting Stallions*, located at the entrance to Brookgreen Gardens. In 1950, the sculpture was created to serve as a landmark, and today it has become the symbol of Brookgreen Gardens.

In 1975, Robert Weinman's design for the third Brookgreen Medal portrayed the history of the property. On the obverse, the image of Theodosia Burr Alston was adapted from a portrait of her by John Vanderlyn. Theodosia was the daughter of Aaron Burr and wife of South Carolina governor Joseph Alston, owner of the Oaks Plantation (now part of Brookgreen Gardens). Her tragic life and mysterious disappearance have intrigued visitors for years.

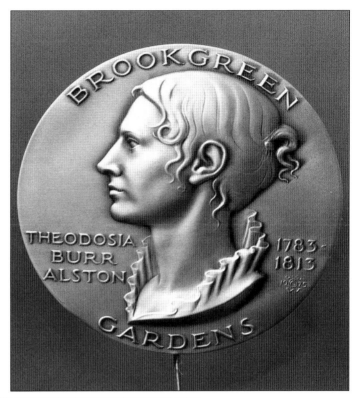

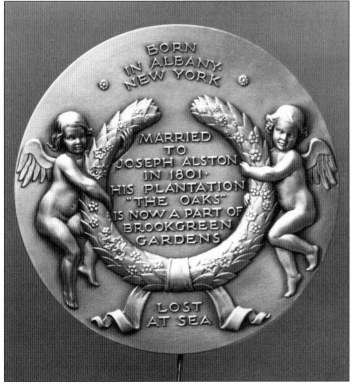

The reverse of this medal contains facts about Theodosia Burr Alston's life presented in the style of an epitaph framed by a wreath supported by cherubs. Robert Weinman made a second, slightly different version of this design that was not chosen. He also initially submitted several sketches using designs adapted from sculpture in the Brookgreen collection, including *Riders of the Dawn* by his father, A. A. Weinman.

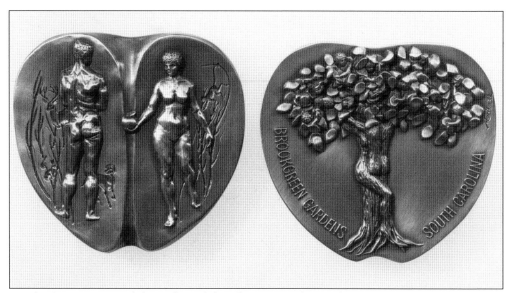

Marika Somogyi created the 17th medal in the series, *Adam and Eve in the Garden*. Designed as two halves of an apple, this medal was the first to deviate from the round format and to be struck in copper. The obverse presented Adam, Eve (holding an apple), and various animals in the background. The reverse depicted the tree of life, the trunk comprised of an entwined female and male with babies in the foliage. The medal was first presented to Brookgreen members in 1987.

Albert Wein is shown in 1991 in his studio with the clay models underway for *Mythology*, the 1993 Brookgreen Medal. Above the board holding the clay models is a reference sketch for the obverse of the medal, portraying the myth of Pygmalion and Galatea. The reverse depicted fauns and nymphs in a woodland setting. The creation of this medal design was somewhat of a race against time. Albert Wein was ill and died shortly after completing the plaster models.

Marcel Jovine, sculptor of the 13th Brookgreen Medal, is shown in his studio working on the plaster models of the designs. Portraying the theme of *The Sculptor at Work*, Jovine's design is one of the most elegant in the series. The obverse is a close-up of a sculptor carving a horse's head in stone with mallet and chisel. The reverse depicts the completed sculpture from the obverse—the winged horse, Pegasus, its wings curving around the edge of the medal. The medal was distributed in 1985.

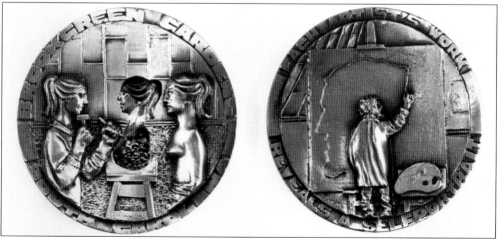

Sidney Simon, creator of the 24th Brookgreen Medal in 1996, was the first sculptor to place himself in the design. The obverse of *Sculptors Create* featured a sculptor with a model, both female, working on a stone carving, shown in intaglio. The reverse showed Simon, his back to the viewer, painting a profile self-portrait. Around the medal's edge is the legend, "Each Artist's Work Reveals a Self-Portrait".

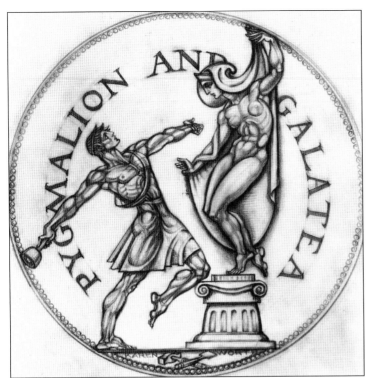

Karen Worth's original drawing for the obverse design and title theme of the 10th Brookgreen Medal told the story of Pygmalion and Galatea, the sculptor who fell in love with his sculpture. This was one of several drawings she submitted as part of the selection process.

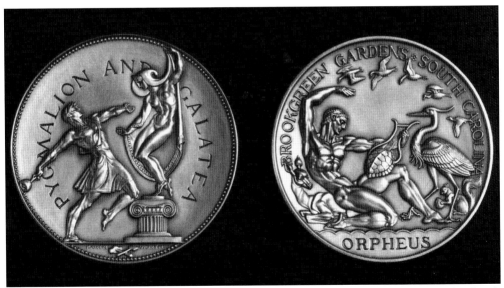

In 1982, Karen Worth's completed bronze medal, *Pygmalion and Galatea*, compared to the sketch shown above, demonstrated the faithful translation from drawing, to clay model, to plaster model, to struck medal. The obverse shows the sculptor, Pygmalion, with his creation, Galatea, at the moment she comes to life. The reverse, celebrating Brookgreen wildlife, depicts Orpheus playing a lyre while surrounded by native animals.

Michael Lantz's design for the seventh medal, *The Ecological Cycle*, featured the food chain of the Lowcountry, with a heron and fish in the center, an alligator moving around the edge of the design toward a frog, and the frog poised to catch a fly. The reverse of the medal depart from the environmental theme and depicted the winged horse, Pegasus, with the addition of a winged colt. *The Ecological Cycle* was presented in 1979.

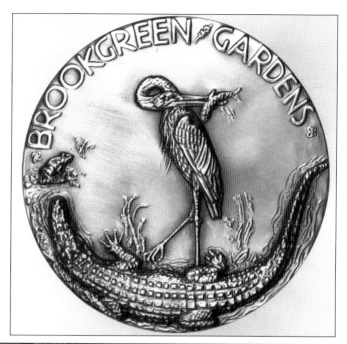

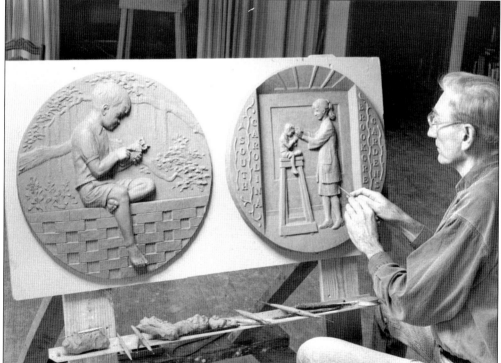

The designer of the 23rd Brookgreen Medal, Charles Parks, selected the theme of childhood for his design. Noted for his sculptures of children, Parks placed a young boy on the openwork brick wall at Brookgreen holding a small sculpture of an owl that he is modeling. The reverse reveals a female sculptor working in her studio on a sculpture of the boy from the obverse. Titled *Children's Sculpture*, the medal was presented in 1995.

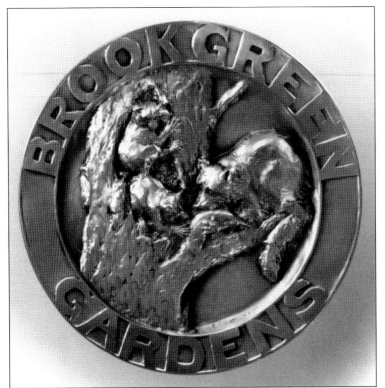

Elisabeth Gordon Chandler designed the Brookgreen Medal for 1997. *Of Forest and Marsh*, the 25th in the series, focused on native wildlife families. Shown here is the obverse design of a mother raccoon bringing a fish to her kits in their den, located in the cavity of a hollow tree.

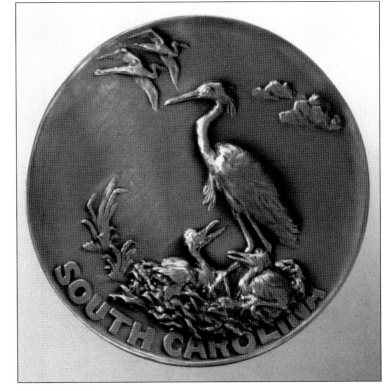

The reverse of the 1997 Brookgreen Medal by Elisabeth Gordon Chandler depicted the nest and a pair of Great Blue Heron chicks with the mother heron standing guard. Two graceful herons fly in the distance, located in the upper area of the design.

In 1984, Chester Martin designed *South Carolina Wildlife*, the 12th Brookgreen Medal in the series. The obverse of his medal portrayed a landscape in coastal South Carolina with Spanish bayonet (*Yucca filamentosa*), cabbage palmetto (*Sabal palmetto*), longleaf pine (*Pinus palustris*), Spanish moss (*Tillandsia usnoides*), and other native species.

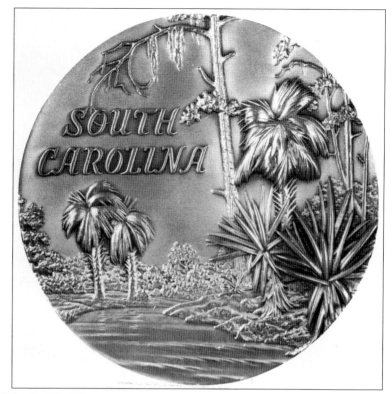

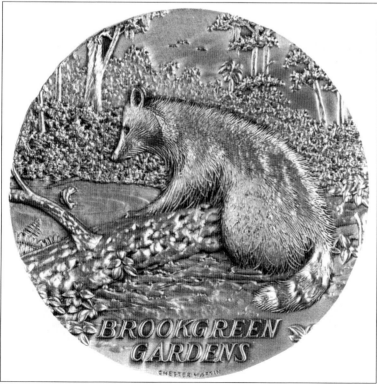

The reverse of *South Carolina Wildlife* by Chester Martin showcased a raccoon in a woodland setting on a fallen tree next to a pond surrounded by coastal South Carolina native plant life. A fish that has just leapt out of the water is eyed by the raccoon. In 1986, Chester Martin became a sculptor-engraver with the United States Mint in Philadelphia.

Eugene Daub designed the 1994 Brookgreen Medal, *The Settler's Medal*, in honor of the original colonists and of the Native Americans found in the region. He is shown in his studio with the clay model of the medal's reverse design portraying a colonist discovering a footprint, which indicates he is not alone. Visible on the far left is part of the sketch for the obverse.

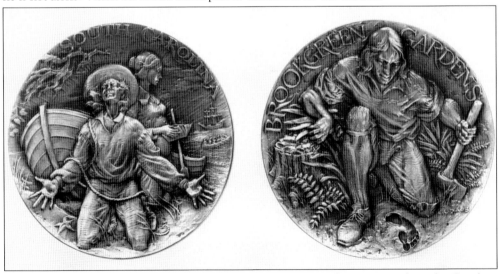

The Settler's Medal by Eugene Daub celebrated the European colonists' arrival on the Carolina coast as well as the Native Americans that were already here. The obverse shows a man kneeling and giving thanks for safe passage while a pregnant woman reads from her Bible. A ship is in the background, and a second dinghy is bringing more passengers. The reverse provides drama in a settler's discovery of a Native American footprint in the sand.

In 1976, the nation's bicentennial celebration produced many medals, including the fourth Brookgreen Medal, designed by Joseph Kiselewski. The obverse of the *Bicentennial Medal* featured Gen. George Washington kneeling in prayer next to his horse. The legend, "Two Hundred Years of the United States of America" encircles the design, and 1776–1976 is across the bottom.

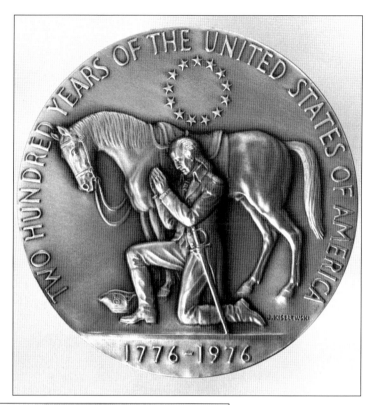

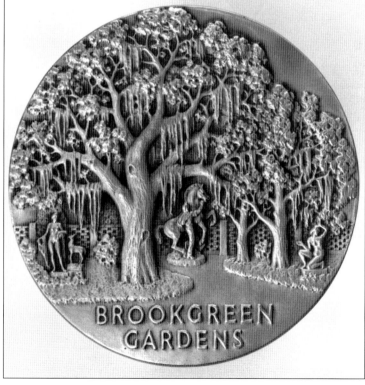

The reverse of Joseph Kiselewski's *Bicentennial Medal* presents a scene in Brookgreen Gardens with the open-work brick wall in the background and moss-draped live oaks interspersed with three sculptures from the Brookgreen collection (from left to right): *Forest Idyl* by Albin Polášek, *Youth Taming the Wild* by Anna Hyatt Huntington, and *Joy* by Karl Gruppe.

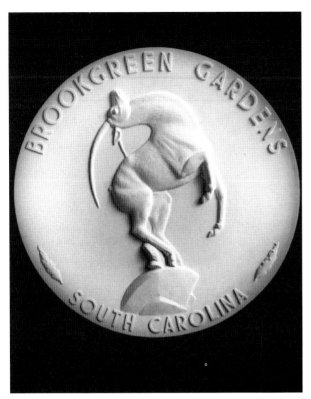

The *Gazelle Medal* by Marshall Fredericks showcased a sculpture from the Brookgreen collection—Fredericks's *Gazelle*, the central figure in the *Gazelle Fountain*, placed in the Arboretum in 1972. The fifth medal in the series, the *Gazelle Medal* was designed in 1977. Its simple design, pictured here in the plaster model, was popular.

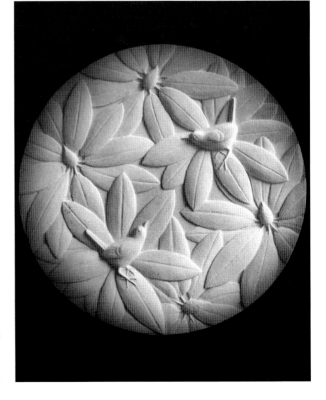

The obverse of Marshall Fredericks's *Gazelle Medal* in 1977 illustrated the plants and animals of South Carolina. Pictured in the plaster model are a pair of Carolina wrens (*Thryothorus ludovicianus*), the South Carolina state bird, perched among boughs of Southern magnolia (*Magnolia grandiflora*). The decorative quality of this side of the medal was also well received.

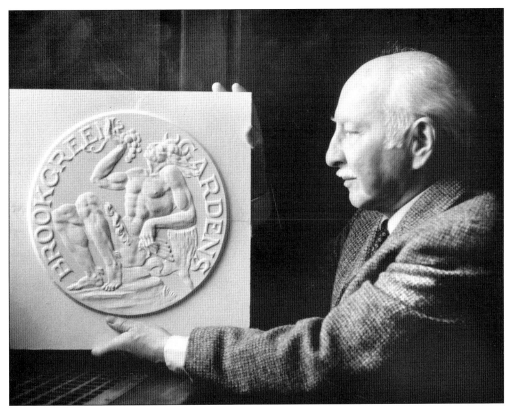

Sculptor Laci de Gerenday, pictured here with the plaster model of the obverse design in 1986, created the 1987 Brookgreen Medal, the 15th in the series. The obverse of *The Mythological and the Real World* presented a grape-eating faun reclining next to a stump and holding a panpipe, representing the mythological world.

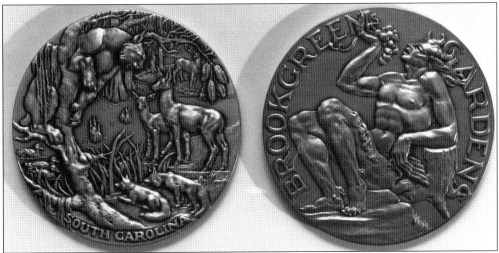

Laci de Geranday designed the 15th medal in the Brookgreen series, *The Mythological and the Real World*, in 1987. The reverse, representing the real world, showed groups of native wildlife in a freshwater swamp setting. Visible clockwise from the top are a bobcat, a buck, a doe and fawn, a pair of foxes, and a group of three mallard ducks.

Joseph Sheppard designed *Inspiration*, the 20th Brookgreen Medal, in 1992. He is pictured in his studio, surrounded by sculpture and drawings, as he works on the clay model for the reverse of the medal design. The obverse showed a seated sculptor contemplating a block of stone while his sculpture idea floats above his head. The reverse depicted the sculptor working on his inspired design, a female figure, carving it from the block.

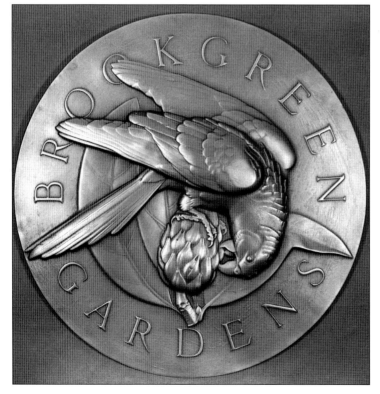

For the second medal in the series, a design was reissued that had been commissioned by Archer Huntington in 1945 and created by Gertrude Lathrop for the Brookgreen board of trustees. The obverse of the *Wildlife Medal* featured the extinct Carolina paroquet perched on a Southern magnolia pod and eating seeds. The reverse (not shown) depicted a recumbent white-tailed deer buck framed by a Southern magnolia seedpod on the left and a magnolia blossom on the right.

In 1978, Donald De Lue, shown with the clay models for the sixth medal, produced the first medal in high relief for Brookgreen. *The Sculptor's Medal* also set the subject parameters for subsequent designs. The obverse (left) shows a sculptor modeling a kneeling figure of Diana, goddess of the moon. The reverse design (right) depicts a sculptor carving a figure of Diana's brother, Apollo, the sun god, with a pair of horses ready to pull his chariot.

Joseph Veach Noble, chairman of Brookgreen's board of trustees from 1976 until 1994, selected the sculptors to design the Brookgreen Medal until 2002. He is pictured in his office at the Museum of the City of New York selecting designs from 36 fully rendered graphite drawings submitted by Donald De Lue for the 1978 Brookgreen Medal.

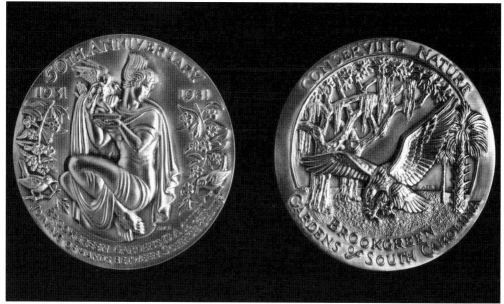

In 1981, Brookgreen Gardens' 50th Anniversary, Abram Belskie was selected to create the medal. The obverse of the design featured a female figure holding a smaller winged figure representing the sculptor. Framing the figure were Carolina wrens in yellow jessamine, the state bird and flower of South Carolina. Around the edges of the design were "50th Anniversary" and "Brookgreen Gardens is a Quiet Joining of Hands Between Science and Art". The reverse showcased a wildlife theme represented by native plants, animals, and the slogan "Conserving Nature."

John Cook designed the 1986 medal, *The Centaur Carver.* The obverse depicted a centaur, his back to the viewer, carving the letters "Brookgreen Gardens" around the edge of the design. The obverse showed a group of centaurs galloping across the field, playing pipes. Their images and the words "South Carolina" are mirrored in intaglio carving across the bottom of the design. This was the 14th medal in the series.

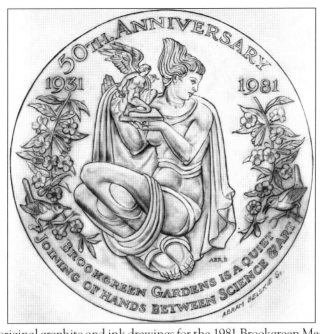

Abram Belskie's original graphite and ink drawings for the 1981 Brookgreen Medal were beautiful works of art themselves. The obverse (above), representing sculpture, revealed the level of detail necessary to create a good design, including uses of the state bird and flower on the sides, and the founding quote from Archer Milton Huntington around the lower edge. The reverse design (below), representing Brookgreen's collections of native plants and animals, focused on its mission of conservation. To depict this goal, Belskie chose the American eagle, a symbol of the country and an endangered species. Another important aspect of the design was the lettering and Belskie's ability to produce it in drawings and sculpture. The inaugural *50th Anniversary Medal* was presented to the Honorable Richard W. Riley, governor of South Carolina.

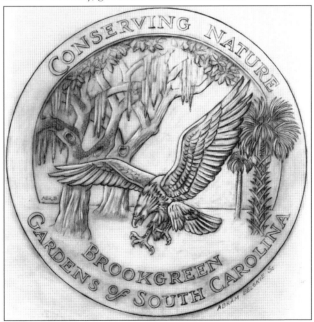

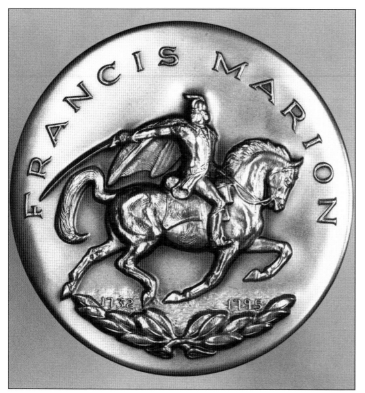

The 1980 Brookgreen Medal, designed by Granville W. Carter, was titled *The Swamp Fox.* Depicting the history of South Carolina, it focused on Gen. Francis Marion, a South Carolina hero of the American Revolution. Carter's design for the obverse shows Marion on his horse, Ball, escaping the British. The image was adapted from a 19th-century engraving by Alonzo Chappel.

Marion's ability to attack the British soldiers, taking them by surprise, then to disappear into the swamps earned him the nickname "the Swamp Fox." He is also considered the father of modern guerilla warfare. The reverse design portrays a native fox in a swamp, representing Francis Marion, devouring a snake, symbolizing the British. Carter's design was produced a year ahead of the medal's debut in order to allow time for the medal to be struck.

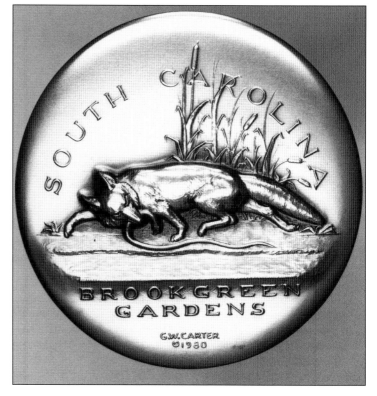

Six

ACQUISITIONS HIGHLIGHTS, 1980–2009

As the collection continues to grow in number as well as stature, many important works have been acquired by Brookgreen Gardens. One of the finest was *The Fountain of the Muses* by Carl Milles, which came to Brookgreen Gardens in 1983 from the Metropolitan Museum of Art in New York. Spearheaded by then-chairman Joseph Veach Noble, Brookgreen's acquisition of the fountain was a landmark in the organization's history.

Time and the Fates of Man by Paul Manship had been located for many years in the gardens at Sterling Forest, an upscale planned community in Tuxedo, New York. It was acquired by Brookgreen at auction in 1980. *Diana* by Augustus Saint-Gaudens was acquired by Brookgreen in 1990, the gift of Joseph Veach Noble in honor of his late wife, Olive. This new edition was authorized to celebrate the 100th anniversary of the original Madison Square Garden, designed in 1890 with *Diana* atop the building.

Some earlier 19th-century gaps in the collection were filled by the acquisition of white marbles, including *The Fisher Boy* by Hiram Powers and *Nydia, the Blind Flower Girl of Pompeii* by Randolph Rogers. The most important early acquisition was *Bacchus*, a small head in white marble by Horatio Greenough, that was not only his first sculpture, done around 1819, but the work was the oldest sculpture in the Brookgreen Gardens collection when it was received in 1993.

Proving that not all important acquisitions are large in scale, *Winter Noon*, created by Anna V. Hyatt in 1903, was acquired in 1994, a gift of Joseph Veach Noble in honor of Gurdon and Ann Tarbox. A small version of the scandalous sculpture *Bacchante and Infant Faun* by Frederick MacMonnies, from 1894, was acquired in 1993, a gift of Joseph Veach Noble in honor of his second wife, Lois.

In 2004, a bequest of New York sculptor Richard McDermott Miller left the contents of his SoHo studio to Brookgreen Gardens. Covering a 50-year career and including more than 600 artworks from tiny to monumental, Miller's gift prompted the creation of the Elliot and Rosemary Offner Sculpture Learning and Research Center, a visible storage facility.

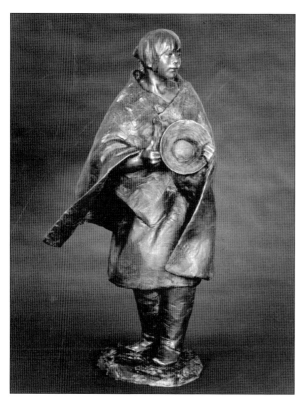

Glenna Goodacre often presents scenes from Native American cultural life in her sculpture. *Basket Dancer*, the study of a figure from a life-size group of three dancers, depicts a Hopi ritual performed by women to celebrate the culmination of planting and a successful harvest. The dancers wear traditional leggings and woven blankets, and carry shallow baskets made of coiled yucca fibers. Created in 1987, the work was acquired in 1996, the gift of Louis and Ann Wright.

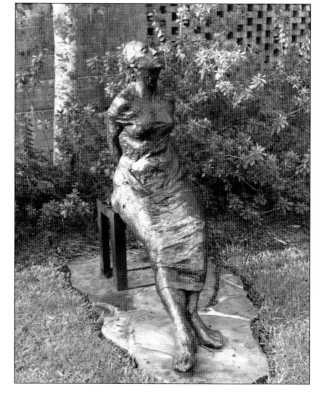

Leonda Froehlich Finke focuses on women as subjects. The images she creates are basic, often left without detail, yet they forcefully convey emotion and expression. In *Seated Woman*, the subject's informal, relaxed posture and the sculpture's rough texture enhance the realism. This sculpture is one of a group of three figures titled *Women in the Sun*, created in 1988. *Seated Woman* was acquired in 1992, the gift of Mrs. Edward M. Rosenthal (Doris).

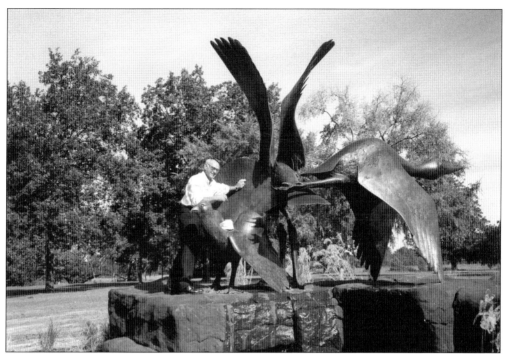

Elliot Offner is pictured with his sculpture *Heron, Grouse, and Loon*, acquired in 2001 and placed in the Arboretum. The sculpture was created for a project in St. Paul, Minnesota, where the birds were placed in a line and mounted on native Minnesota granite. That was not feasible for this placement, so a base of simulated rock was fabricated to support the massive figures, a recircling waterfall was installed, and each bird was repositioned to achieve a more compact grouping. *Heron, Grouse, and Loon* was a gift from the family of Austin Kelley.

Bacchante and Infant Faun was created by Frederick MacMonnies in 1894 and was placed in the courtyard of the Boston Public Library. For more than a year, newspapers carried letters to the editor about the unseemly nudity, drunkenness, and despoiling of the sacred theme of mother and child. Finally it was removed by the donor and given to the Metropolitan Museum of Art. In 1993, a small version of the sculpture was donated by Joseph Veach Noble in honor of his wife, Lois, pictured here.

Anna Hyatt Huntington's older sister, Harriet, was the first sculptor in the Hyatt family. Specializing in portraits and memorial plaques, Harriet modeled this portrait bust of Anna at the age of 19 in 1895. The bust was cut in marble and remained in the family until 1990, when it was donated to Brookgreen Gardens by Brantz Mayor, a son of the artist. Another example is in the collection of the American Academy of Arts and Letters.

The Wounded Comrade, depicting an injured bull elephant supported by two females, was immediately successful after Carl Akeley created it in 1913. The qualities of animal love and compassion, themes central to many of Akeley's bronze works, are shown in the tenderness of one rescuer's trunk curled protectively over the wounded animal's face. The sculpture was acquired in 1992, the gift of Robert V. Hatcher Jr.

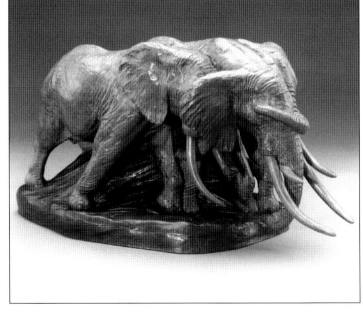

114

Bacchus by Horatio Greenough was the first work by this important early American sculptor. The sculpture was carved about 1819, when the sculptor was 14 years old. Greenough had given the work to his college roommate, Paul Trapier, and it remained in the Trapier family in Charleston, South Carolina, until 1993, when Beatrice Gilman Proske gave the sculpture to Brookgreen.

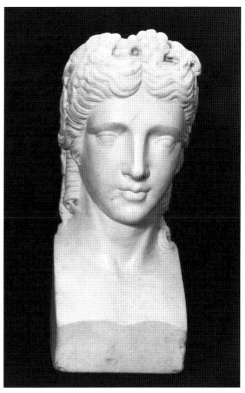

Among the first pieces to bring recognition to Anna V. Hyatt was *Winter Noon*, a pair of workhorses huddled against the wind. Immediately popular, it was widely exhibited and acquired. In 1904, the sculpture was shown in an exhibition at the Louisiana Purchase Exposition at Saint Louis and, in 1915, at the Panama-Pacific Exposition in San Francisco. *Winter Noon* was acquired in 1994, the gift of Joseph Veach Noble, in honor of Gurdon and Ann Tarbox.

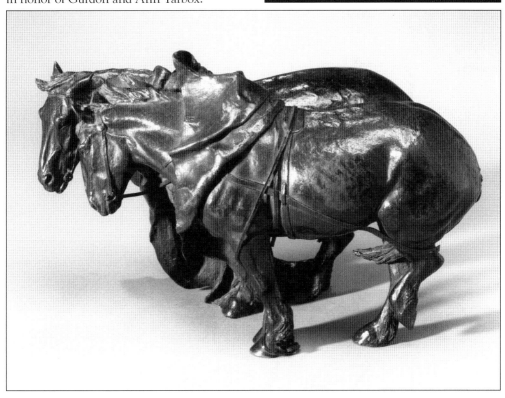

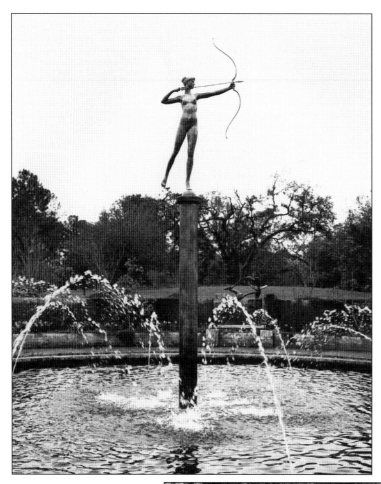

One of the best-known works by Augustus Saint-Gaudens, *Diana* has sparked controversy since her creation in 1893. Placed atop the original Madison Square Garden, the initial figure was an ungainly wind vane with billowing drapery. A second, streamlined version was designed to successfully replace the earlier work. This posthumous casting, authorized to celebrate the 100th anniversary of Madison Square Garden, was acquired in 1990, the gift of Joseph Veach Noble in memory of his first wife, Olive.

Black Panther by Anna Hyatt Huntington was created in 1958 as a mascot for the 353rd Fighter Squadron headquartered at the Myrtle Beach Air Force Base. When the Squadron was deactivated in 1992, the sculpture came to Brookgreen and was placed adjacent to Opuntia Pond. In 1994, the squadron was reactivated, and the sculpture was returned to the U.S. Air Force and sent to Eileson Air Force Base in Fairbanks, Alaska.

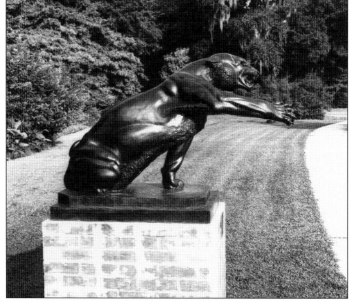

Love's Memories by Thomas Ball, an important 19th-century sculptor, was created in 1875. One of the popular works acquired for Victorian parlors and gardens, *Love's Memories* was the personification of carefree youth and innocence. The angelic young boy in the guise of Cupid, and his casual, somewhat careless pose, appealed to the dichotomy of straitlaced Victorian life. It was acquired in 1993 and was shown in Brookgreen's first traveling exhibit, American Masters: Treasures from Brookgreen Gardens.

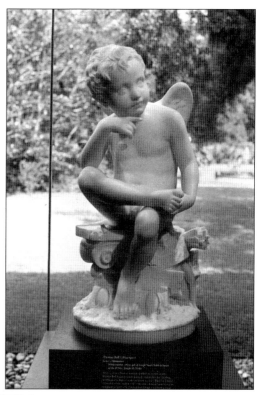

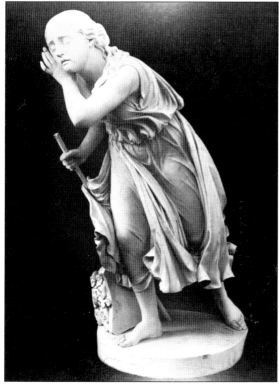

Randolph Rogers's *Nydia, the Blind flower Girl of Pompeii* was created in 1855. Nydia is shown confused and disheveled as she tries to find her way through the debris-littered streets of Pompeii during the eruption of Mount Vesuvius. Based on a character from the novel *The Last Days of Pompeii* by Edward Bulwer-Lytton, *Nydia* was Rogers's most popular sculpture. The work was acquired in 1988.

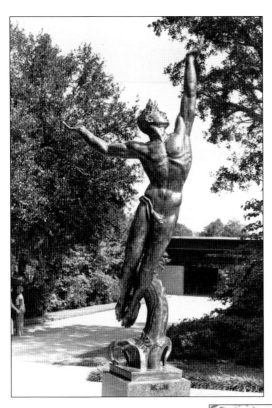

Spirit of American Youth by Donald De Lue is the half-size model for the 22-foot-tall monument at the Normandy American Cemetery and Memorial in St. Laurent-sur-Mer, France. Commemorating those who lost their lives on D-Day during the invasion of Normandy, the work was commissioned by the American Battle Monuments Commission in 1949. The sculpture carries the subtitle *Mine Eyes Have Seen the Glory of the Coming of the Lord.* The sculpture was acquired in 1981 and was placed on the walkway to the Visitors Pavilion.

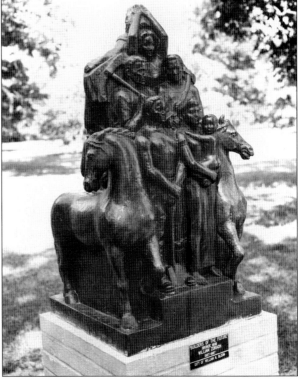

Builders of the Future was created by William Zorach for the 1939 New York World's Fair. It embodied the slogan of the fair, "Building the World of Tomorrow." A seminal figure in American art in the 20th century, Zorach was known as a wood and stone carver as well as a modeler. *Builders* was acquired in 1982, the gift of William N. Bloom.

Several works by Charles Parks were acquired as gifts while he served on Brookgreen's board of trustees. *Sunflowers*, a fanciful depiction of a girl playing a flute while seated on a large sunflower, was created in 1974 and was purchased by the Equitable Life Assurance Society of the United States for its New York City headquarters. The society donated it to Brookgreen in 1984, and the work was placed in the Peace Garden Room for Children.

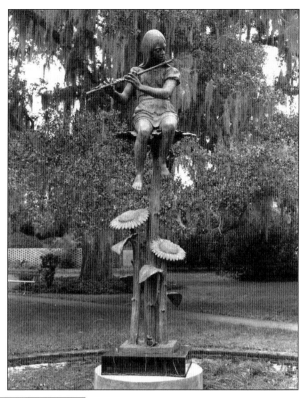

Marshall Fredericks also served on the Brookgreen board of trustees and made his work available. The sculpture that is best loved by the public is *The Wings of the Morning*, based on Psalm 139: 9–10. The sculpture was acquired in 1989, the gift of the sculptor, and was placed on the walkway between the lower left wing and the Muses Garden area. Marshall Fredericks is shown at the sculpture's dedication.

119

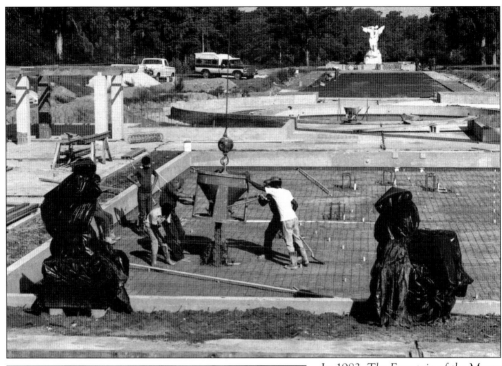

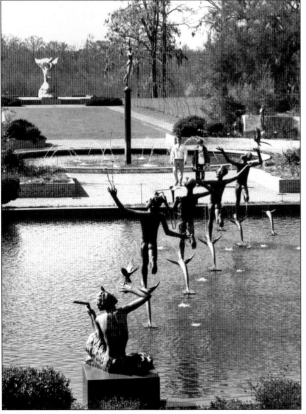

In 1983, *The Fountain of the Muses* by Carl Milles was acquired by Brookgreen Gardens from the Metropolitan Museum of Art, and in 1984, it was placed in its own garden designed by landscape architect Taft Bradshaw of Lauderdale-by-the-Sea, Florida. Workmen (above) are preparing the rectangular pool by pouring the concrete bases on which the main figures will be placed. Part of the pergola system is visible on the left, the circular pool is located mid-ground, and *Pegasus* by Laura Gardin Fraser is in the background. The completed garden (left) is shown with five primary figures on a diagonal line, *Diana* by Augustus Saint-Gaudens placed in the center pool and *Pegasus* by Laura Gardin Fraser (left) in the distance. Also visible (right) is *Flight* by Richard Recchia in the raised bed.

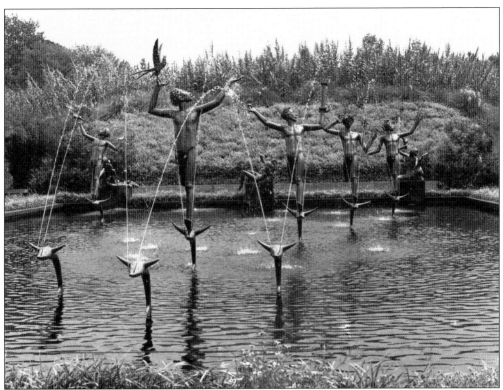

The Fountain of the Muses was the last
large sculpture project by Carl Milles,
begun in 1949 and completed just
six months before his death in 1955.
Comprised of 15 individual bronze figures,
the work was modeled and cast in Italy
for the dining room of the Metropolitan
Museum of Art in New York. The five
figures in the pool represent branches
of the arts (from left to right): sculptor,
poet, architect, musician, and painter.

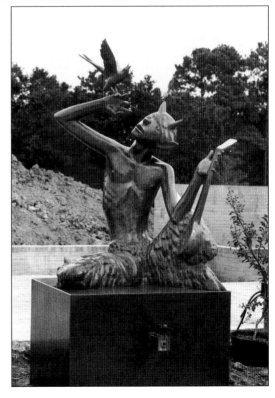

The Faun from The Fountain of the Muses
by Carl Milles is located on the edge
of the rectangular pool. According to
the sculptor, the Faun, a mythological
character that is half man and half goat,
is taking music lessons from the bird
perched on his hand. This photograph
was taken before most of the plantings
had been installed, including those
on the berm behind the sculpture.

Time and the Fates of Man by Paul Manship was the monumental centerpiece of the 1939 New York World's Fair. Exhibited in plaster and later destroyed, this huge sundial was never cast in bronze. With a gnomon 80-feet in length, it was considered the largest sundial in the world at the time of its installation.

In 1980, Brookgreen acquired a unique bronze casting of a smaller model of *Time and the Fates of Man*, depicting the three Greek fates—Clotho, Lachesis, and Atropos—who determined each man's destiny. Its gnomon is 27-feet in length. The sculpture was installed in 1981 in the Arboretum.

After moving from Ohio to New York City in the 1950s, Richard McDermott Miller steadily found his vision and voice in sculpture. By the 1990s, he was known as the "figure sculptor of SoHo" and was acclaimed for his depiction of the female figure. He wrote, "although I'm involved with the facts of the body—its anatomy and so forth—I am more interested in seeking its form."

In 2004, Richard McDermott Miller left the contents of his New York studio to Brookgreen Gardens. Along with sculpture, drawings, and other objects came archival material to document his work. This photograph shows an installation of a solo show of Miller's over-life-size work at the Artists' Choice Museum in New York.

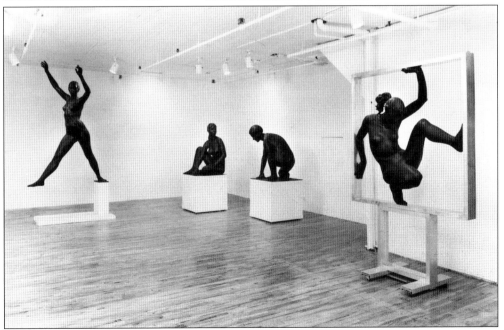

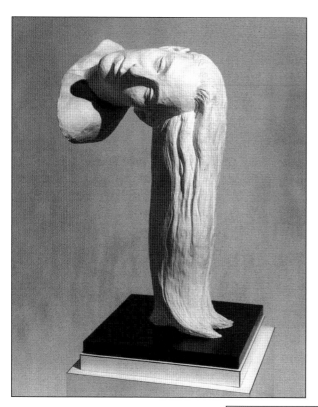

Composer, singer, and choreographer Meredith Monk modeled for Miller in the mid- and late 1960s. This plaster sculpture from 1969 is part of a larger composition where the model leaned to her side and her hair touched the floor. Miller utilized the long, flowing hair as a support for the head, creating an unusual and startling pose for a portrait.

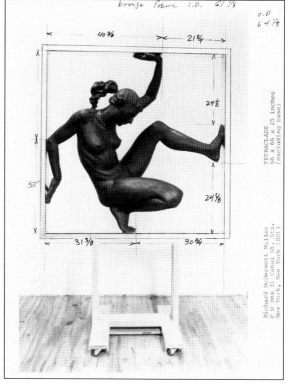

Tetraclade by Richard McDermott Miller depicts a device that he used in a series of sculptures—placing a figure within a frame. Sometimes the figure relaxes in the frame; sometimes it fights and pushes against it. Miller often provided measurements on photographs for potential clients. *Tetraclade*, done in 1986, was donated to Brookgreen by the sculptor in 2004, shortly before his death.

Richard McDermott Miller is shown in his studio in New York City in the 1960s. His gift of the contents of his studio at the end of 2004 prompted the creation of the Elliot and Rosemary Offner Sculpture Learning and Research Center at Brookgreen Gardens. There, much of his work can be seen on risers, pedestals, and in large display cases.

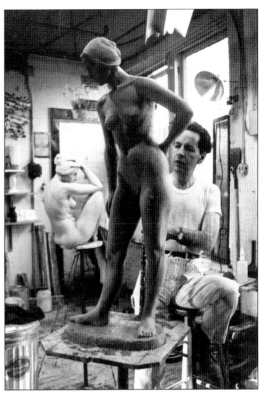

Winning, a series of three figures presenting the stages of a race, was modeled in 1982 from photographs of runner Jesse Owens. The sculpture was cast in bronze in 1990. The original wax model, 14-inches tall, is in the collection of Brookgreen Gardens and can be seen in the Offner Center. The large sculpture in bronze pictured here is in the National Service Industries Building in Atlanta, Georgia.

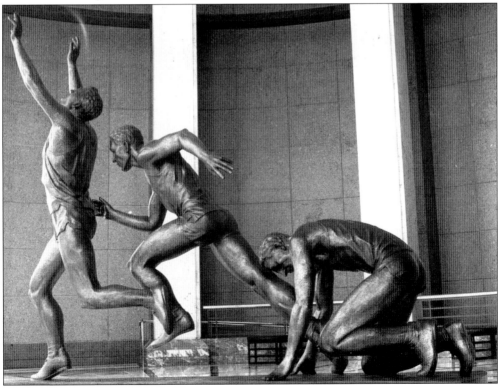

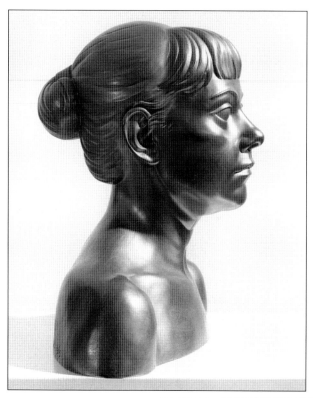

Richard McDermott Miller's body of work included portraits, such as the one (left) of his wife, Gloria Bley, a writer, done in 1965. The graphite plaster of the portrait is in the collection of Brookgreen Gardens. The bronze is in the family's possession. The portrait (below) of Paul Resika, a painter and friend of the sculptor, was modeled in 1971. The wax model of the portrait is in the Brookgreen collection. The bronze casting is in the subject's possession.

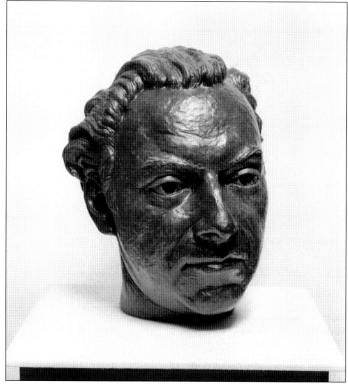

The Spacewalker is a one and a half-times life-size bronze figure posed by Janice Mauro. Created in 1979, it represents Richard McDermott Miller's focus on the female figure and his quest for innovative and unusual presentations in sculpture. Pictured here in his studio, it was donated to Brookgreen Gardens prior to his death in 2004 and was placed adjacent to Jessamine Pond.

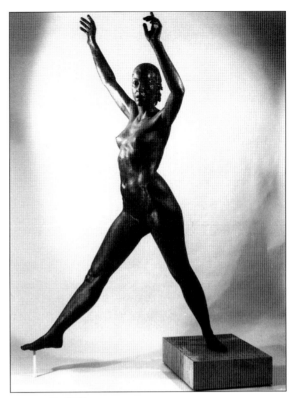

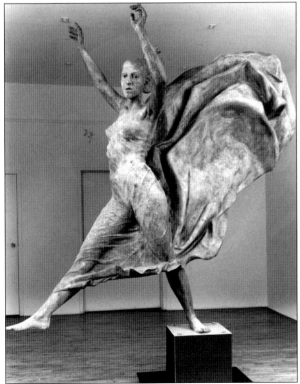

Wind on the Water, a monumental figure done in 1991, was donated to Brookgreen Gardens in 1994 by its sculptor, Richard McDermott Miller. The work is the same figure as the one shown above in *The Spacewalker* with the addition of the billowing drapery. The sculpture is pictured here in Miller's New York studio. It was placed on Jessamine Pond at Brookgreen Gardens.

127

www.arcadiapublishing.com

Discover books about the town where you grew up, the cities where your friends and families live, the town where your parents met, or even that retirement spot you've been dreaming about. Our Web site provides history lovers with exclusive deals, advanced notification about new titles, e-mail alerts of author events, and much more.

MADE IN THE

Arcadia Publishing, the leading local history publisher in the United States, is committed to making history accessible and meaningful through publishing books that celebrate and preserve the heritage of America's people and places. Consistent with our mission to preserve history on a local level, this book was printed in South Carolina on American-made paper and manufactured entirely in the United States.

This book carries the accredited Forest Stewardship Council (FSC) label and is printed on 100 percent FSC-certified paper. Products carrying the FSC label are independently certified to assure consumers that they come from forests that are managed to meet the social, economic, and ecological needs of present and future generations.

FSC
Mixed Sources
Product group from well-managed forests and other controlled sources

Cert no. SW-COC-001530
www.fsc.org
© 1996 Forest Stewardship Council

Find Your Place in History.